D1327502

chronotopes & dioramas

Dominique Gonzalez-Foerster

Atlantic – Desert – Tropics

Atlantic

Auster, Paul. *Ghosts*. 1986. Reprint, New York: Penguin Books, 1987.

Casares, A. B. *La invención de Morel*. 1940. Reprint, Buenos Aires: Emecé, 1972. *

Cozarinsky, Edgardo. *Vudú urbano*. 1985. Reprint, Buenos Aires: Emecé, 2007.

García Lorca, Federico. *Poeta en Nueva York*. 1936. Reprint, Granada: Comares, 2001.

Kafka, Franz. *Amerika*. 1927. Reprint, Frankfurt am Main: Suhrkamp, 2007.

Sebald, W. G. *Die Ausgewanderten*. 1992. Reprint, Frankfurt am Main: Fischer, 2008.

Stein, Gertrude. *Geography and Plays*. 1922. Reprint, Mineola, New York: Dover, 1999.

Vila-Matas, Enrique. *Bartleby y compañía*. 2000. Reprint, Barcelona: Anagrama, 2008.

* Collection of the Hispanic Society of America, New York

A Buenos Aires, les jours rallongent lorsque arrive septembre. Tu n'y as jamais pense, n'est-ce pas ?

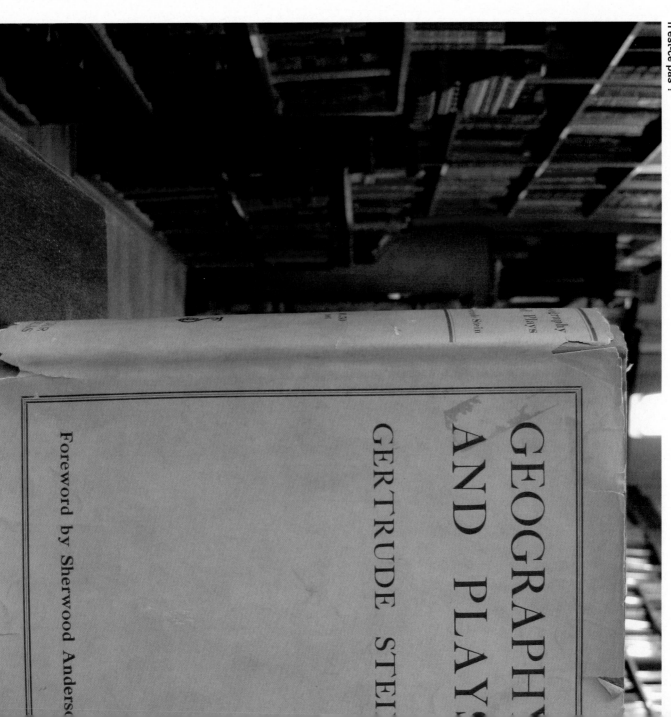

Foreword by Sherwood Anderso

GEOGRAPHY AND PLAYS

GERTRUDE STEI

that starts with the Atlantic, continues in the desert, and gets lost in the forest.

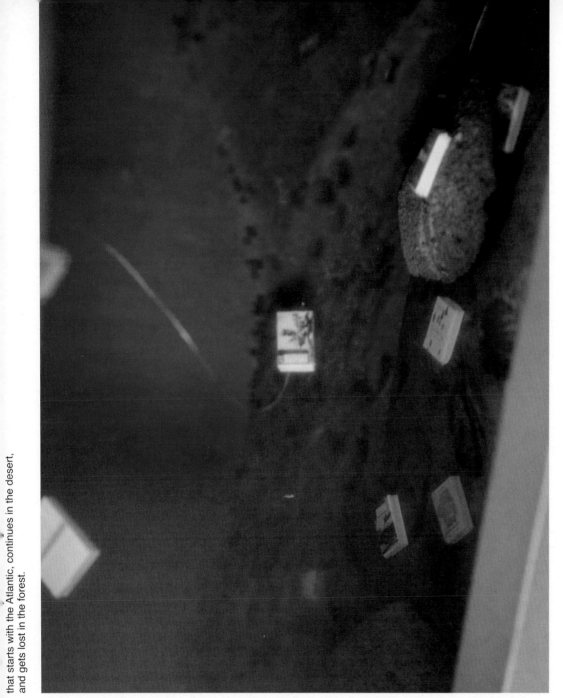

aqua incognita

the climate library

the mental library / Ballard

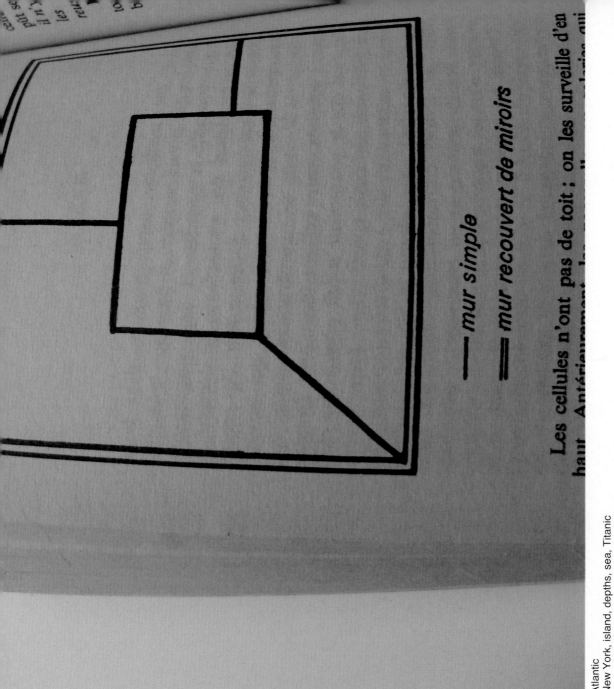

—— mur simple

=== mur recouvert de miroirs

Les cellules n'ont pas de toit : on les surveille d'en haut. Antérieurement les

Atlantic
New York, island, depths, sea, Titanic
Emigrés, blue cube – urban melancholy

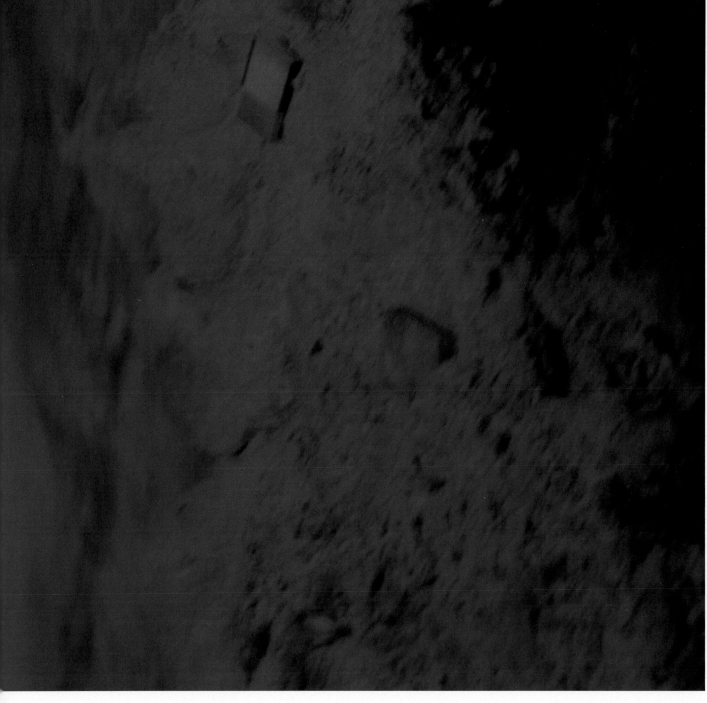

North America is a continent separated from Asia by the Bering Strait and by the Pacific Ocean, then from Europe and Africa by the Atlantic Ocean; it is bound in the north by the Arctic Ocean and in the south by the Antarctic Ocean.

ATLANTIC
the blue is perfect
it looks very deep
i like the position of the object in the back
maybe the "rock" or relief on the left side is a bit too
high and closes the seascape too much but maybe
it's necessary for the illusion, it could be a bit lower...
to stay more in a desertic liquid void impression
like on the sketch
the one on the right is perfect

PANORAMA, COSMODROME, EXPODROME, NOCTURAMA,
DIORAMA

late 19th-century precinema explorations

BLUE CUBE – water cube – blue cube – underwater – cinema
aquatic scenes and underwater scenes of artificial intelligence,
of Titanic – Solaris –
WHITE CUBE – white cube – desert – MUSEUM

GREEN CUBE – green cube – forest – park

J. G. Ballard – *Hello America* – the 3 spaces
ATLANTIC – DESERTIC – CLIMATIC
crossing the Atlantic – the desert of New York and the
tropical forest of Las Vegas – literature of climatic disturbances
everything is a space – the Fourierian utopia of Sontag's America
Kafka's fictional nightmare – Butor's *Mobile*

psychogeographic voyages
in the California deserts and New Mexico
the tropical forest and Rio de Janeiro
Atlantic, aquatic space of the unconscious and of the voyage

Adolfo
Bioy Casares
La invención
de Morel

Cambié los discos; las máquinas proyectáran la
nueva semana, eternamente.
Adolfo Bioy Casares

Desert

Bolaño, Roberto. *2666*. 2004. Reprint, Barcelona: Anagrama, 2009.

Bolaño, Roberto. *Los detectives salvajes*. 1998. Reprint, Barcelona: Anagrama, 2009.

Borges, J. L. *Ficciones*. Buenos Aires: Ediciones SUR, 1944.*

Bradbury, Ray. *The Martian Chronicles*. 1946. Reprint, New York: Time, 1963.

Castaneda, Carlos. *The teachings of Don Juan: A Yaqui Way of Knowledge*. 1968. Reprint, New York: Ballatine Books, 1973.

Fante, John. *Ask the Dust*. 1939. Reprint, New York: Ecco, 2002.

Herbert, Frank. *Dune*. New York: Ace Books, 1965.

Johnson, Dorothy M. *The Hanging Tree*. 1951. Reprint, New York: Ballantine Books, 1979.

Scarborough, Dorothy. *The Wind*. 1925. Reprint, Austin: University of Texas Press, 1979.

* Collection of the Hispanic Society of America, New York

ASK THE DUST

JOHN FANTE

I carried the book a hundred yards into the desolation, toward the southeast. With all my might I threw it far out in the direction she had gone. Then I got into the car, started the engine, and drove back to Los Angeles.
John Fante

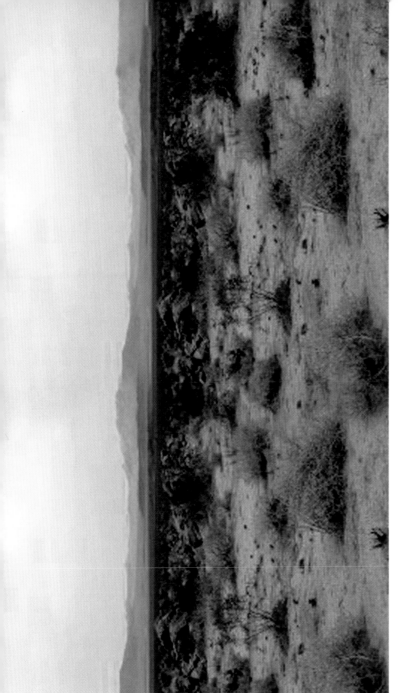

climate hypothesis

climarama

dioramas

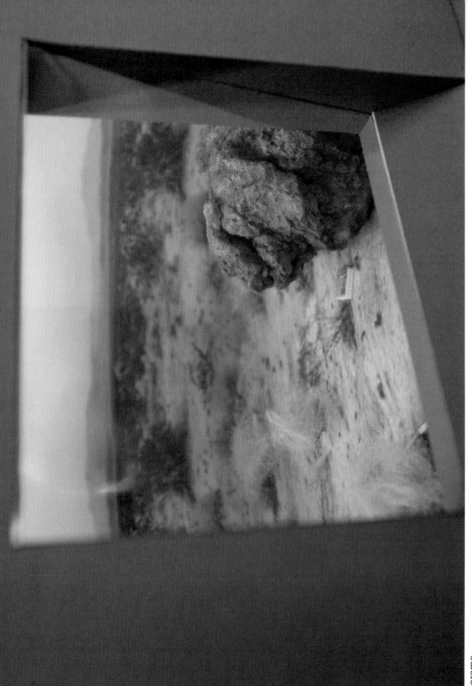

diorama

books and climate

J. G. Ballard's books
films of cooling, cyclone, storm
climatic changes
climate-induced artistic states

dates
facts

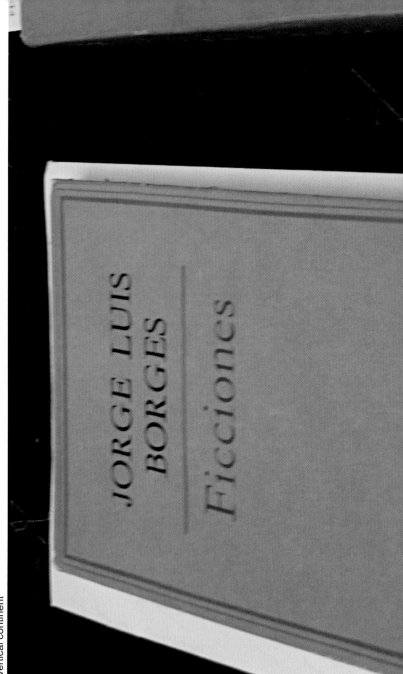

Ballard, Bolaño, Sebald, Vila-Matas
climatic fiction, crossed states
"tes etats d'ame eric, sont comme les etats d'amerique"
climatic continent
the vertical continent

desertic
Atomic Park, New Mexico, Los Angeles
Mexican white cube, conceptual, artistic, radical

DESERT
it looks great, i only wonder
if the architecture/ruin is not too present.
maybe it could be a bit smaller, or far away.
by the way, do you know Mary Colter, the architect?
and her incredible ruinlike constructions.
i like the elements in the front and the mount on the right.

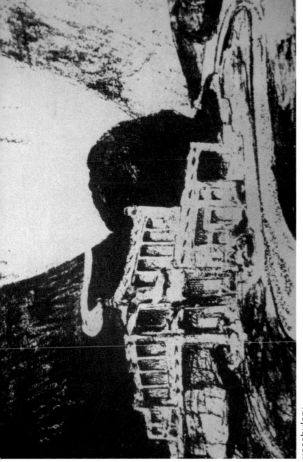

vocabulary
psychogeography
expanded literature –
the impossibility of being a writer

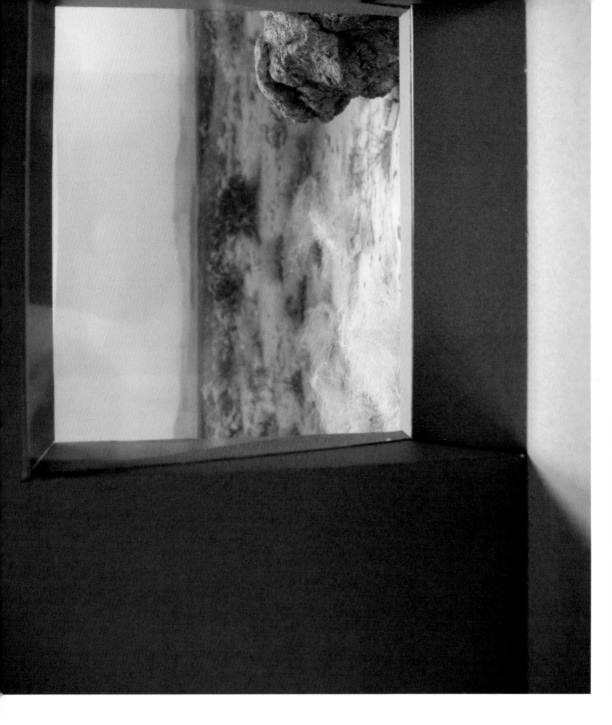

SPACE PRODUCING TEXT – TEXT PRODUCING SPACE
the space that generates the text
the text that generates the space
space-text

de la littérature américaine

1939-1989

Fayard

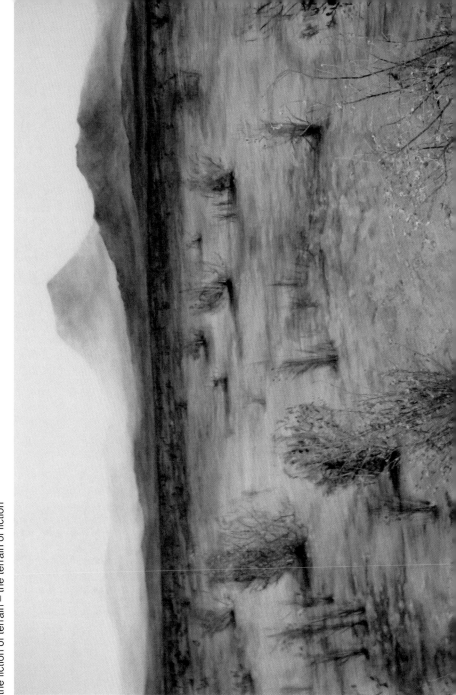

the fiction of terrain – the terrain of fiction

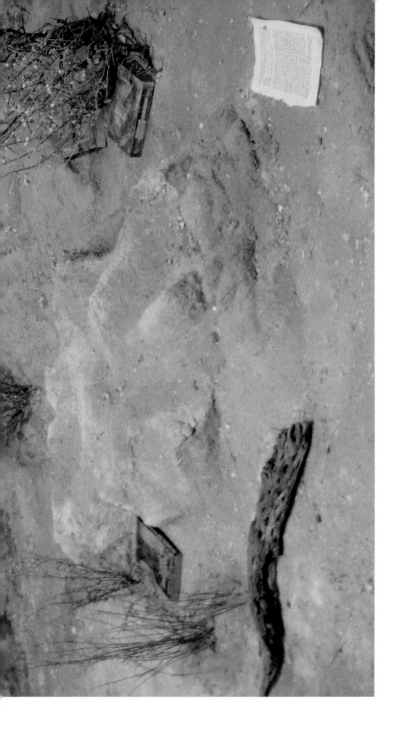

A WALL PAINTING – LIKE THE MURALIST – A LITERARY FRESCO
REVISIT BEGINNING NOTES
a literary fresco mural with the writers' signs/notations
or a Lascaux-type fresco,
like the horn of *Lot 49*

Roberto Bolaño

Los detectives salvajes

and the drawings of Roberto Bolaño, Adolfo Bioy Casares,
but also the photographic interruptions of Sebald
and the maps/diagrams of Stendhal in *The Life of Henry Brulard*
Nabokov's American journey

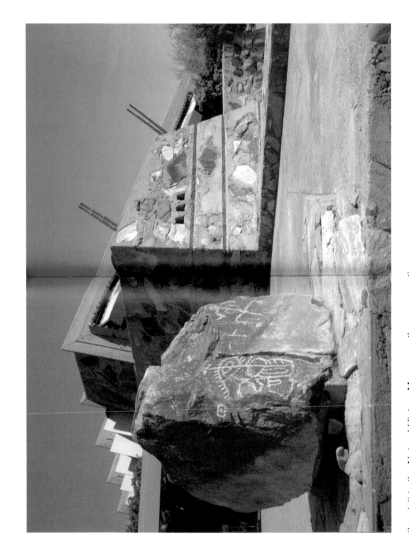

the visit to the Natural History Museum – the conservation
and the invention of the report from the countryside (revisit dioramas book)
the big national parks – giant fragments of display

Hispanic Society
the *Citizen Kane* effect, the European libraries,
the Irish librarian, and the modernist research trail
155th Street, the end of the city

other sources:
contextual architecture – climatic – geographic
of Mary Colter – the Grand Canyon's ruins, Lina Bo Bardi
and also Albert Frey, Palm Springs – Frank L. Wright

cinema
Citizen Kane, the collection, and Xanadu

the valley/forest of Barbet Schroeder and Werner Schroeter
films of aquatic or climatic deluge
like the day after the flood in the library
the films of the desert, water, and forest

Smithson – documents and books on *Spiral Jetty – Hotel Palenque*
Land Art – Walter De Maria and On Kawara – diorama and chronotope
Gordon Matta-Clark
three big writers like
Lawrence Weiner and On Kawara – George Brecht
Felix Gonzalez-Torres and his lists
the big literary texts from the end of the twentieth century

¿Que hay detrás de la ventana? Bolaño

9 de febrero

Volvemos al Impala, volvemos al desierto. En este pueblo he sido feliz. Antes de irnos Lupe dijo que podíamos regresar a Villaviciosa cuando quisiéramos. ¿Por qué?, le dije. Son asesinos, nos acepta. Son asesinos, le digo, igual que nosotros. Porque la gente de hablar, dice Lupe. Los de Villaviciosa tampoco, es una manera de hablar, dice Lupe. Los de Villaviciosa tampoco, es una como te quiero, pero a nosotros nunca nos encontrará. Ay, Lupe, como te quiero, pero ¿por qué equivocada estás.

10 de febrero

Cucurpe, Tuape, Meresichic, Opodepe.

11 de febrero

Carbó, El Oasis, Félix Gómez, El Cuatro, Trincheras, La Ciénega.

12 de febrero

Bamuri, Pitiquito, Caborca, San Juan, Las Maravillas, Las Calenturas.

13 de febrero

¿Qué hay detrás de la ventana?

14 de febrero

¿Qué hay detrás de la ventana?

Una sábana extendida.

15 de febrero

¿Qué hay detrás de la ventana?

Tropics

Andrade, Mário de. *Namoros com a medicina.* 1939. Reprint, Belo Horizonte, Brazil: Itatiaia, 1980.

Andrade, Mário de. *O movimento Modernista.* Rio de Janeiro: Casa do estudante do Brasil, 1942.*

Andrade, Mário de. *Os contos de Belazarte.* 1934. Reprint, Rio de Janeiro: Agir, 2008.

Andrade, Oswald de. *A escada.* São Paulo: Globo, 1991.

Andrade, Oswald de. *Marco Zero I: a revolução melancólica.* São Paulo: Globo, 1991.

Andrade, Oswald de. *Primiero caderno do aluno de poesia.* 1991. Reprint, São Paulo: Globo, 1994.

Ballard, J. G. *Hello America.* London: Jonathan Cape, 1981.

Bishop, Elizabeth. *Geography III.* 1976. Reprint, New York: Farrar, Straus and Giroux, 2008.

Bowles, Paul. *Up Above the World.* 1966. Reprint, New York: Pocket Books, 1968.

Brautigan, Richard. *The Abortion: An Historical Romance 1966.* 1970. Reprint, London: Vintage, 2002.

Burroughs, William. *The Naked Lunch.* 1959. Reprint, London: Corgi, 1974.

Burroughs, William S. *Naked Lunch: The Restored Text.* Ed. James Grauerholz and Barry Miles. 1959. Reprint, New York: Grove Press, 2001.

Conrad, Joseph. *Almayer's Folly.* 1895. Reprint, London: J. M. Dent, 1995.

Conrad, Joseph. *Heart of Darkness.* 1899. Reprint, London: Penguin Books, 1995.

Delany, Samuel. *Babel 17.* 1966. Reprint, New York: Ace Books, 1974.

Dick, Philip K. *The Man in the High Castle.* 1962. Reprint, New York: Berkley Medallion, 1974.

Dick, Philip K. *The Man in the High Castle.* 1962. Reprint, New York: Berkley, 1985.

Dick, Philip K. *Ubik.* 1969. Reprint, New York: Bantam, 1977.

Gaddis, William. *Carpenter's Gothic.* 1985. Reprint, London: Atlantic Books, 2003.

Glissant, Édouard. *Pays rêvé, pays réel.* 1985. Reprint, Paris: Gallimard, 1994.

Le Guin, Ursula K. *The Word for World Is Forest.* 1972. Reprint, New York: Berkley Medallion, 1976.

Lispector, Clarice. *Água Viva.* 1973. Reprint, Rio de Janeiro: Rocco, 1998.

Lispector, Clarice. *A hora da estrela.* 1977. Reprint, Rio de Janeiro: Rocco, 1998.

Nabokov, Vladimir. *Ada or Ardor: A Family Chronicle.* 1969. Reprint, London: Penguin, 2000.

Nin, Anaïs. *Delta of Venus: Erotica.* 1969. Reprint, New York: Bantam Books, 1983.

Pynchon, Thomas. *The Crying of Lot 49.* 1965. Reprint, New York: HarperCollins, 2006.

Smith, Patti. *Babel.* 1974. Reprint, New York: G. P. Putnam's Sons, 1978.

Stein, Gertrude. *The Making of Americans.* 1925. Reprint, Normal, Illinois: Dalkey Archive, 2006.

Vila-Matas, Enrique. *Historia abreviada de la literatura portátil.* 1985. Reprint, Barcelona: Anagrama, 2007.

Vonnegut, Kurt. *Slapstick.* 1976. Reprint, New York: Delta, 1977.

Wurlitzer, Rudolph. *Nog.* 1968. Reprint, Columbus: Two Dollar Radio Movement, 2009.

* Collection of the Hispanic Society of America, New York

Tropical notes

"Forget," muttered Almayer; and that word started before him a sequence of events, a detailed programme of things to do.
CONRAD

JOSEPH CONRAD
Heart of Darkness

diorama travel

books in landscape

following the model of a Stendhal map/diagram

Finha c'è l'avevo coi pescatori perché quello non è il modo di pescare, poi con me stesso per avere spa-rato, terzo con quel tuo amico là e poi ancora coi pescatori... Delle volte sento una tale rabbia di fronte agli altri, a pensare come dovrebbero essere e a vedere invece come sono. Mi pare che finché gli altri non saranno padroni di se stessi, non lo sarò neanch'io.

Un uomo su un mulo imbocca una stradina scon-nessa.

E poi si dice che il mondo cambia, che cambia trop-po in fretta.

Certo che cambia. In peggio ma cambia. Almeno finché non avremo un'idea piú chiara di quello che dovrebbe essere.
Ma la politica è questo.

T'ha uno scatto di insofferenza.

La politica!

Sembra che faccia fatica a frenarsi. Con la mano dà dei pugni sempre piú forti sulla sponda della jeep. È evidente che l'amico ha toccato un tasto delicato.

La politica, mio caro amico, è quella scienza in cui le domande sono sempre di piú e le risposte sem-pre di meno, ecco cos'è.

Psychogeography
there are climates, geographic situations
environments
but also psychological states
atlantic, desert, tropical

to think of Stendhal/Ballard
the map of the landscape and of my mind
in which zone does a book or a writer go
a psychoregionalist approach
a psychogeographic, literary world atlas

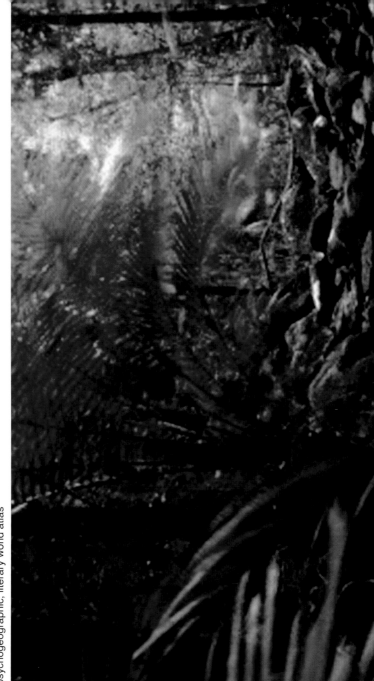

tropical
Brazil, Rio de Janeiro, Brisbane, Asia, tropicalization
green cube, proliferating, fertile, sexual

Foi porque nunca tivemos gramáticas, nem coleções de velhos vegetais. E nunca soubemos o que era urbano, subur-
bano, fronteiriço e continental. Preguiçosos no mapa-múndi do Brasil.

North America, located in the Northern Hemisphere, including Canada, the United States, and Mexico

Central America and the Caribbean Islands

South America, located in the Southern Hemisphere, is broken by an invisible equinoctial line called the Equator

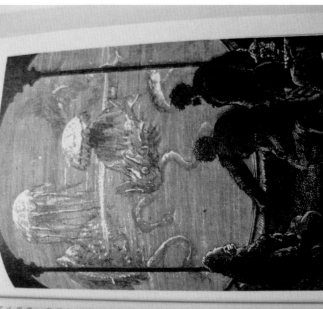

ique se produsait au sein même le Na
plus de l'eau lumineuse, mais de la

pothèse d'Erhemberg, qui croit à une
orescente des fonds sous-marins, li
t réservé pour les habitants de la me
odigieux spectacles, et j'en poura
le jeux de cette lumière. De chaqu
nêtre ouverte sur ces abîmes ine
u salon faisait valoir la clarté ext
ions comme si ce pur cristal eût et
aquarium.

mblait pas bouger. C'est que le
nquaient. Parfois, cependant, le
par son éperon, filaient devant no
se excessive.

ions accoudés devant ces vitrine,
encore rompu ce silence de stup-
dit :

ami Ned, eh bien, vous voyez!
x ! faisait le Canadien — qui
es projets d'évasion, subissait un
et l'on viendrait de plus loin pour

je comprends la vie de cet hom-
de à part qui lui réserve ses plu

fit observer le Canadien. Je n

TROPICAL
maybe the house could be a little more on the right (less central)
and bit more distressed/destroyed or hidden
i'm not completely sure about the black/dark elements
that are more horizontal, some kind of dark wood
in the center maybe a bit too present and
it creates a strange grid effect
it might be better to remain more vertical, but maybe its
very present because of the picture (detail)
it already works better on the 3-dioramas view

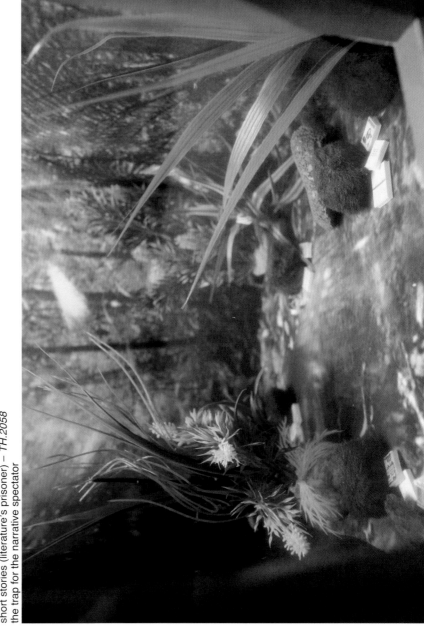

BOOK AS MATERIAL – PHYSICAL AND CONTENT
BRICKS – PILES – CATALOGUES

library 1985 – *tapis de lecture* – *roman de münster*
short stories (literature's prisoner) – *TH.2058*
the trap for the narrative spectator

FILMS IN WHICH THE CLIMATE AND NOT ONLY THE URBAN
CONTEXT PLAYS A STRONG ROLE
films:
atomic park (desert) – Taipei (rain) – gold (desert) – beaches (tropical)

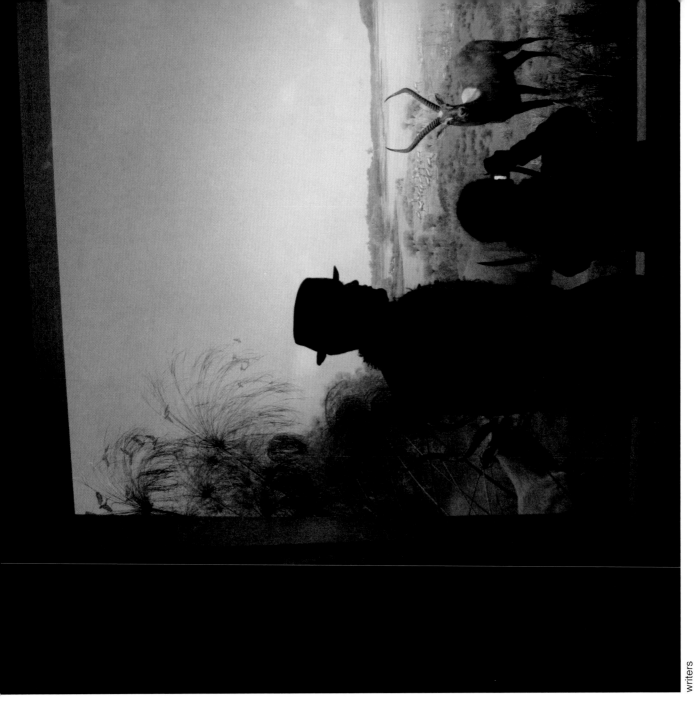

writers
Helene Bessette – Clarice Lispector – new bibliography
Georges Perec – *Species of Spaces*
open dialogue with Enrique Vila-Matas – the link with Bolaño and Sebald
the American writers like William Gaddis (*Carpenter's Gothic*),
Wallace Stevens, Philip K. Dick, Brautigan
Dorothy… (western) – Dorothy Scarborough – the wind

but also John Fante and Gertrude Stein

Andrade, Mario de
O movimento...

MARIO DE ANDRADE

O MOVIMENTO MODERNISTA

RIO DE JANEIRO
1942

PRINTED IN BRAZIL

Deleuze's interest in American literature on displacement/citation
American history in the literature of Petillon – Philippe Garnier
the space of Borges and Adolfo Bioy Casares

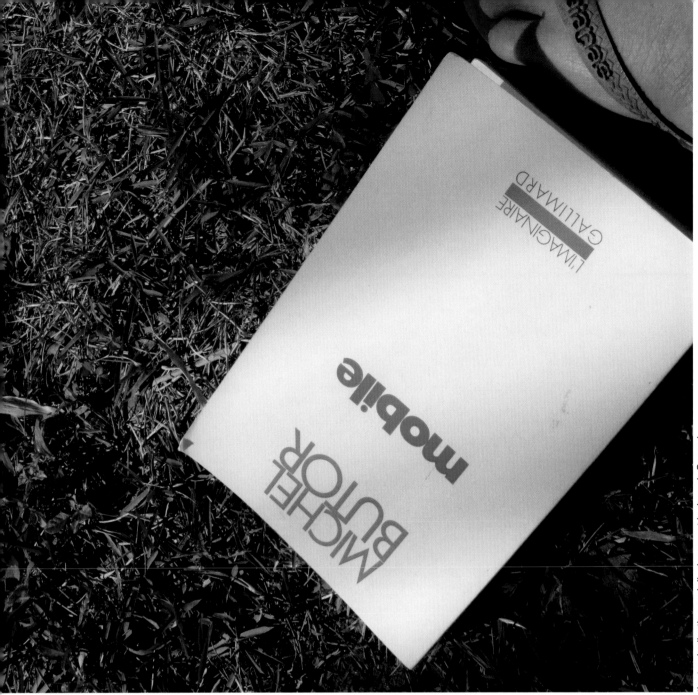

the tropicalization and displacement in Joseph Conrad

Philip K. Dick, Brautigan, Ray Bradbury, and American space

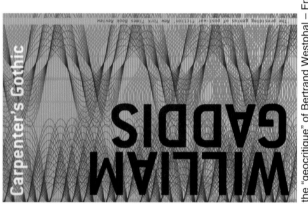

Carpenter's Gothic

WILLIAM
GADDIS

the preceding genres of post-war fiction / New York Times Book Review

the "geocritique" of Bertrand Westphal – Franco Moretti – the literary atlas
the allusions to Brazilian geographies
Paul Ricoeur – Jameson

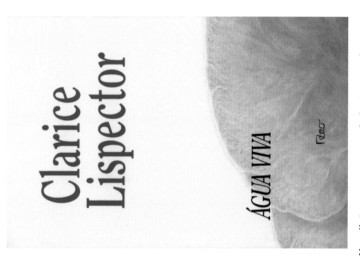

Clarice
Lispector

ÁGUA VIVA

Rocco

Ne m'interesse que ce qui n'est pas moi...
loi de l'anthropophage.

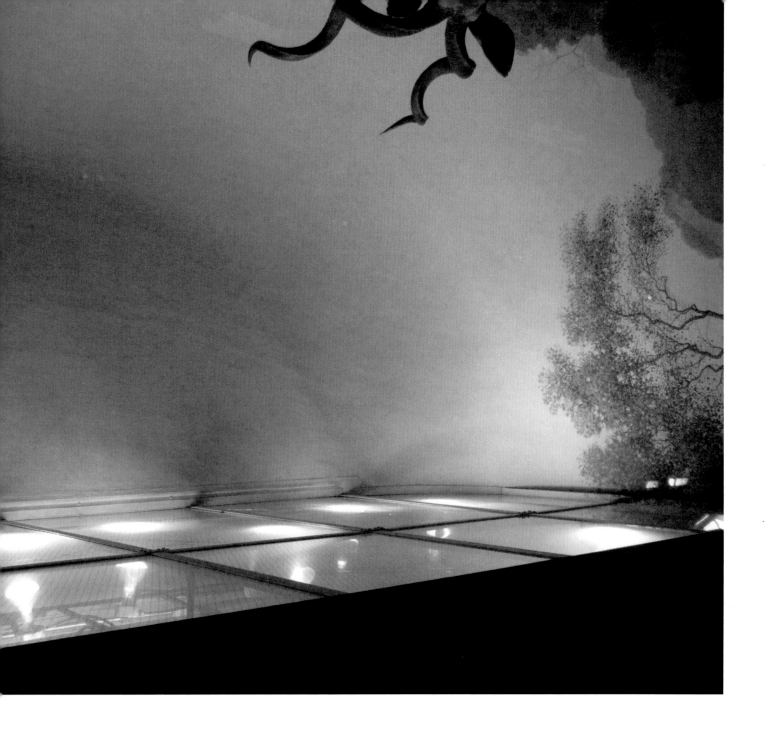

Special thanks to The Hispanic Society of America.
This program is generously supported by public funds from
the New York City Department of Cultural Affairs; New York
City Councilmember Robert Jackson; Etant donnés: The
French-American Fund for Contemporary Art (a program
of FACE); The Kadist Art Foundation; and Erica and
Joseph Samuels.

This book was published on the occasion of the exhibition
"Dominique Gonzalez-Foerster: chronotopes & dioramas,"
organized by Dia Art Foundation, New York, at Dia at
the Hispanic Society of America, September 23, 2009–
June 27, 2010.

Book design by Filiep Tacq, Madrid
Editors, Lynne Cooke and Karen Kelly,
with Barbara Schröder
Assistant editor, Jeanne Dreskin
Proofreading by Sam Frank

© 2010 Dia Art Foundation, New York
535 West 22nd Street, New York NY 10011
www.diaart.org

All rights reserved. No part of this publication may be reproduced or
transmitted in any form or by any means, electronic or mechanical,
including photocopy, recording, or any other information storage
and retrieval system, or otherwise without written permission from
Dia Art Foundation.

ISBN 978-0944521-57-1 (Dia Art Foundation, New York)

Library of Congress Cataloging-in-Publication Data

Gonzalez-Foerster, Dominique, 1965-
 Chronotopes & dioramas / Dominique Gonzalez-Foerster ;
with texts by Lynne Cooke ... [et al.].
 p. cm.
 Published on the occasion of an exhibition organized by
Dia Art Foundation, New York which was held at the
Hispanic Society of America, Sept. 23, 2009-June 27, 2010.
 Includes bibliographical references.
 ISBN 978-0-944521-57-1 (alk. paper)
 1. Gonzalez-Foerster, Dominique, 1965—-Exhibitions. 2.
Words in art—Exhibitions. 3. Diorama—New York (State)—
New York—Exhibitions. 4. Site-specific installations (Art)—
New York (State)—New York—Exhibitions. I. Cooke,
Lynne, 1951- II. Dia Art Foundation. III. Hispanic Society of
America. IV. Title. V. Title: Chronotopes and dioramas.
 N6853.G598A4 2010
 745'.8092—dc22
 2010017726

Distributed by
D.A.P./ Distributed Art Publishers
155 Sixth Avenue, 2nd Floor
New York, NY 10013-1507
1-800-338-BOOK
www.artbook.com

Printed in Belgium
by die Keure, nv

Photo credits:

All artwork by Dominique Gonzalez-Foerster
© 2010 Dominique Gonzalez-Foerster
Artists Rights Society (ARS), New York/ADAGP, Paris

Cover and endpapers:
Photos by Cathy Carver, New York

Atlantic—Desert—Tropics:
All images by Dominique Gonzalez-Foerster, except the
following: #7 in Atlantic photo by Francesca Esmay;
#8 in Desert, drawing by Mary Colter, 1916, Grand Canyon
National Park Museum Collection #16683, NPS Photo;
#13 in Desert © 2010 Frank Lloyd Wright Foundation,
Scottsdale, AZ / Artists Rights Society (ARS), New York;
#16 in Desert photo by Francesca Esmay; #7 in Tropics
courtesy Instituto Lina Bo e P. M. Bardi.
Pages 46 and 47, courtesy The Hispanic Society of America,
New York; page 49, courtesy American Museum of Natural
History, photo by Denis Finnin and Roderick Mickens;
page 50, photo by Lothar Schnepf, courtesy of the artist and
Esther Schipper, Berlin; page 51, photo © Tate, London,
2010, courtesy of the artist and Esther Schipper, Berlin;
page 55, © 2010 Daniel Buren / Artists Rights Society (ARS),
New York/ADAGP, Paris, courtesy of the artist, photo by
Daniel Buren; page 57 (top), © Estate of Robert Smithson /
Licensed by VAGA, New York; page 57 (bottom), courtesy of
the artist, photo by Bill Jacobson; page 58, © 2010 ADAGP,
Paris, Succession Marcel Duchamp, Artists Rights Society
(ARS), New York, courtesy Philadelphia Museum of Art;
page 59, courtesy American Museum of Natural History,
New York, photo by Denis Finnin.

Drowned book:
Photos by Dominique Gonzalez-Foerster

Textorama:
Photo by Cathy Carver, New York; details by Dominique
Gonzalez-Foerster

Dia Art Foundation, New York

DIA ART FOUNDATION

Board of Trustees

Nathalie de Gunzburg,
 Chairman
Christopher M. Bass
Frances Bowes
Sandra J. Brant
Constance R. Caplan
Frances R. Dittmer
Donald R. Mullen, Jr.
Alden Pinnell
Bradford J. Race
Howard Rachofsky
Robert Ryman
Christine Stanton
Jimmy Traboulsi
Charles B. Wright
Jan Cowles,
 Emeritus
John C. Evans,
 Emeritus
Fariha Friedrich,
 Emeritus

Staff

Kathleen Anderson
Rendell Archibald
Sarah Bachelier
Chad Bowen
Carolyn K. Carson
Jennifer Casamassima
Elizabeth Clark
Lynne Cooke
Micheal Covello
Karey David
Kurt A. Diebboll
Patti Dilworth
Bill Dilworth
Jeanne Dreskin
Christine Drisgula
Francesca Esmay
Steven Evans
Michael Faison
Laura Fields
Kady Fonseca
Valerie French

Heidie Giannotti
Jennifer Haines
Grant Haffner
Curtis Harvey
Patrick Heilman
Karen Kelly
Shaun Lawler
Eduardo Leon
 de la Hoz
Claire Lofrese
Teresa Lopez
Jon Patrick Murphy
Katy Peace
Ty Marshall Pitoniak
Kristin Poor
Laura Raicovich
Yasmil Raymond
Rebecca Rice
Charles Rodstrom
Jill Petrush Rogers
Amy Sandback

James Schaeufele
Caroline M. Schneider
Barbara Schröder
Kathleen Shields
Gustavius Smith
Katie Sonnenborn
John Sprague
Ashley Tickle
Melissa Toth
Sara Tucker
Philippe Vergne
Mark Walker
Robert Weathers
Susan Zawoluk
Fernando J. Zelaya

As of April 2010

Preface

As I am writing these lines, a volcano in Iceland, emitting clouds of ashes, is disrupting the affairs of the globe. It is suspending air traffic in Europe—and thus, in effect, everywhere else—halting trade and transaction, threatening public health, and underscoring the fragility of modern culture, our sense of progress, and our relationship with nature. Seismic activity seems more intense and omnipresent to many of us than it has in a long time—after recent devastation in Chile, Mexico, Indonesia, and especially Haiti; it is as if nature were reminding us of its existence, as if it were bestowing on us one last occasion in which to reimagine our dialogue with it. Recently Alan Weisman in *The World Without Us* described a place where most human achievements—architectural, technological, cultural, artistic—crack and collapse in a chain reaction of disaster, and nature takes over, spinning out of control. Weisman's apocalyptic vision, which renders our Icelandic volcano a harmless smoke signal, is not a tale of science fiction. It is simply science. The fiction is ours, the one of our belief in progress at any or all cost.

Somehow, Dominique Gonzalez-Foerster's installation *chronotopes & dioramas* elicits these thoughts, without being about them. A "textorama" of literary migrations, at once poetic, playful, and melancholic, maps a cultural legacy in space and time, while introducing a trio of dioramas: the Atlantic, the desert, the tropics. Each of these landscapes hosts an ambiguous architectural structure, ambiguous because it is difficult to determine whether it is about to collapse or whether it is in the process of being erected. The buildings evoke those of Lina Bo Bardi in the tropical forest, of Frank Lloyd Wright and Taliesin West in the desert, and of Jules Verne and Japanese Metabolist architecture in the ocean. Their settings are populated, not by beings, mammalian or otherwise, as in conventional natural-history-museum dioramas, but by books with their voices, stories, and histories, which all relate in some way to the specific location they inhabit. The human body is notably absent, for the only presence of a body is that of text. These bodies behind the glass, inaccessible to us, occupy their own ecological, geological, tectonic space. For an artist whose work has often been about the time and the space dedicated to words, the anachronistic form of the diorama seems an accurate medium; for it is a theater designed to narrate what once was or what will be; it is a representation of a time to come that belongs in the past (also a common attribute of science fiction). Gonzalez-Foerster's dioramas formalize an entropic space for books and knowledge, a shelter for an endangered species.

It would be a mistake to limit this project to any singular interpretation, however. In fact, Gonzalez-Foerster may not be meditating on an apocalyptic disappearance of literature, knowledge, and reading; she may not be pointing a finger at the crisis of the book as a medium for the diffusion of ideas. She may instead be suggesting that books are at the root of representation. She may also be reminding us that words are meant to be seen as much as they are to be read, as those artist-writers of modernity, like Lewis Carroll, Guillaume Apollinaire, Marcel Broodthaers, Augusto and Haroldo de Campos, Carl Andre, and others, have displayed. Gonzalez-Foerster's *chronotopes & dioramas* might just be about the space—psychological, subjective, physical, and emotional—

created by stories and words. To read her own words about this work—in both the "atlas" of notes and images and the commentary alongside Lynne Cooke's essay in this book—is to enter a prism where literature, film, and art are the apparatus for a *raconteuse* who narrates the story of stories and histories. Gonzalez-Foerster is a storyteller who has carved a hybrid environment for literature in an expanded field.

My deepest thanks go to the artist, for this exhibition and this book, for the trust she put in Dia, and for her rigorous dedication to identifying and expanding on the conventions of showing and telling.

I am indebted to Nathalie de Gunzburg and Dia's Board of Trustees for their support and enthusiasm for this project and to the Dia staff for putting the full force of their effort behind the project's realization. I am especially grateful to Lynne Cooke, Dia's curator at large, who, in the spirit of Dia's long tradition of commissioning new works, invited Dominique to create a project for the Hispanic Society and then engaged the artist in the dialogue that resulted in *chronotopes & dioramas*. This exhibition and this book would not have happened without her sensitivity and commitment to the artist's vision.

In dialogue with Dominique and Lynne were assistant curator Kristin Poor and conservator Francesca Esmay, who together led a team that also engaged conservation technician Heidie Giannotti and buildings manager John Sprague. Stephen Christopher Quinn, the lead diorama artist at the American Museum of Natural History, was kind enough to share invaluable lessons in the optics of dioramas and introduced us to Joianne Bittle Knight, who skillfully designed and constructed the wondrous dioramas with Dominique and Dia's staff after architectural plans by Martial Galfione and models by Helene Chapeau. Conservation intern Cynthia Albertson assisted in the documentation of the dioramas in anticipation of a future installation. Meanwhile, graphic designer Marie Proyart worked with Dominique on the lyrical layout of the textorama. Composer Arto Lindsay treated the guests to Dia's Fall Gala to a three-part performance inspired by the trio of dioramas.

This book was conceived as another space in which to explore and manifest Dominique's project. Novelist Enrique Vila-Matas, a friend and recurrent collaborator, has woven the three dioramas into an enigmatic voyager's tale, while author Bradford Morrow considers *chronotopes & dioramas* as an encounter with his old friends, the novels encased in the dioramas and their authors. We are indebted to each for their notable contributions. The book was edited, with careful consideration of the project's layered themes, by Lynne and Karen Kelly, Dia's director of publications, in partnership with Barbara Schröder and Jeanne Dreskin. Upon Dia's invitation to Filiep Tacq to design this book, Dominique asked him to contemplate the history and future of the book form itself, a challenge that resulted in an inspired collaboration with the artist and editors. The result belongs to a history of distinguished publications of which Dia is proud.

Mitchell Codding, director of the Hispanic Society, has been a wonderful partner in this the third of several projects in a series that Dia produces in the spaces of the society's building on Audubon Terrace. The society's board of trustees and its staff have been most cooperative, and we could not be more grateful for such a smooth collaboration between our two institutions. In particular, John O'Neill, Curator of Manuscripts and Rare Books, welcomed the artist into the institution's library and offered invaluable research.

Esther Schipper has lent significant assistance to this project, for which we are enormously grateful. The exhibition and this accompanying publication were also generously supported by public funds from the New York City Department of Cultural Affairs; New York City Councilmember Robert Jackson; Etant donnés: The French-American Fund for Contemporary Art (a program of FACE); The Kadist Art Foundation; and Erica and Joseph Samuels.

Philippe Vergne
Director, Dia Art Foundation

This title has not yet been released.

mid-february 2010 • starting to work on the content of this book • the same book you are holding now in your hands • i realized that it was already possible to order it even though the content was still completely unclear • unfinished and partly undefined • but nobody knew about that of course except for the few people working on this book • i ordered one sample to stimulate myself • but it only added more confusion about what should be in this book and why this book could or would make sense • part of the diorama's content is about how books will survive or disappear • and it shows them as living beings affected • and generated by climate and geographical environments, like any other species • there was a strange gap between a book about books that didn't yet exist and a book that does exist • a gap that takes place in a moment where a longtime existing idea is suddenly becoming more real • electronic books • there is a temptation to present a kind of "last book" • a book about books being endangered • but because of this glum climate • i realized this book couldn't have a finished aspect • it shouldn't be the last of a kind but rather something different • unplanned and alive, escaping the grid of a planned extinction • the material inside should be very alive and should fight against the idea of a finished book • it should contain unexpected possibilities • it shouldn't be what it should have been • but rather something else, a surprise for you and me.

Thanks also to:

Maurizio Cattelan, Tommaso Corvi-Mora, Martial Galfione, Nicolas Ghesquière, Pierre Huyghe, Yoshiko Isshiki, Lisette Lagnado, Eduardo Lago, Benoit Lalloz, Emma Lavigne, Denise Milfont, Jan Mot, Philippe Parreno, Esther Schipper, Hans Ulrich Obrist, and Philippe Rahm.

Dominique Gonzalez-Foerster

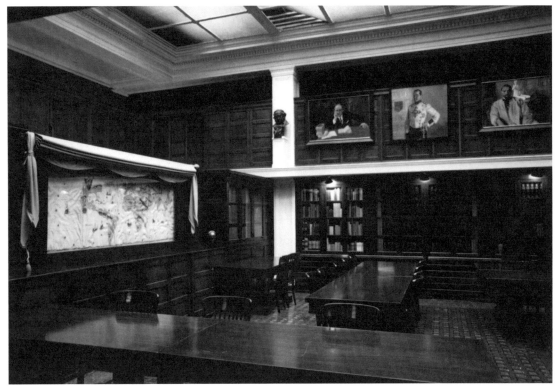

Reading room and library, The Hispanic Society of America, New York.

FRAMEWORKS

Lynne Cooke, with a commentary by Dominique Gonzalez-Foerster

As opposed to more autonomous works, an exhibition
requires a context. It's a medium of contexts. For me,
context now has a more historical dimension. I see it
more as a time-based issue than a space-based issue.

— *Dominique Gonzalez-Foerster*

Founded at the beginning of the twentieth century by a private
collector fascinated by all things Spanish, the Hispanic Society
of America focuses on material culture from the Iberian Peninsula.
Containing Neolithic artifacts, medieval ceramics, Renaissance
painting, Baroque embroidery, and much else, its internationally
renowned collection covers a broad disciplinary range. Devised
by its founding patron, Archer Milton Huntington, these displays
are for the most part still in place in the building he designed
in collaboration with his cousin the architect Charles Pratt
Huntington. They include wall cabinets containing regional
crafts in wood-paneled galleries and a side room festooned with
a flotilla of medieval and Renaissance locks and hinges. In the vast
central hall, paintings, sculptures, plaster casts, and textiles from
the Middle Ages to the Baroque commingle in a dense Salon-style
hanging. A suite of monumental paintings commissioned from
Joaquín Sorolla y Bastida, once considered Spain's preeminent

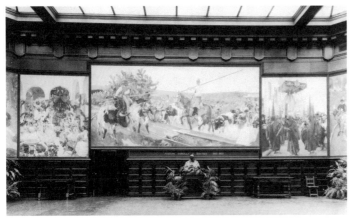
Sorolla gallery in 1926, The Hispanic Society of America, New York.

early twentieth-century master, dominates an adjacent gallery
that, until recently, also housed a vast photographic archive of
ethnographic material. ◻ Huntington was, moreover, an avid bib-
liophile and amassed an extensive library. Assembled partly from

◎

Even before seeing the library, my first
impression of the Hispanic Society of
America was a completely cinematographic
one. The room filled with the art collection
is overwhelming: the way it's presented is
far from the types of presentation we're
used to now. I suddenly had the feeling
I was in *Citizen Kane*, on that strange
platform where access is denied to the
newsreel reporter, Jerry Thompson.
It was a *Citizen Kane* moment.

◻

I don't know why I started to imagine
working in the manner of the Mexican
muralists. I was influenced in part by the
Sorolla gallery, where there is a series of
huge paintings—a panorama—showing
different Spanish regions. At that time,
I was doing some specific research on
literature in which a sign appeared that
was not a known cipher. One obvious
example comes from Thomas Pynchon's
The Crying of Lot 49, in which you find
a little horn symbol, which is a sign of a
system of undercover communication.
I was hunting for books that have signs
that are not alphabetical or that have
incredible little maps like in Stendhal's
autobiographical work *The Life of Henry
Brulard*, where the text is accompanied by
little plans. In this book, the protagonist
manages to go back into his memory of
his early life by drawing a map of his

grandfather's apartment. It's a method I've also tried: you start by thinking, okay, here is the corridor, and here is the room, and then suddenly you start to see the bed, and suddenly you remember the painting over the bed. . . . (There are many other examples, such as those in W. G. Sebald's books, where images play a strange role.) So, mixing this memory of Sorolla with my search for signs in literature, I started to imagine a kind of wall drawing in which you would see some writers together with the signs. But I'm not a painter, and it's very difficult to go back into the past—into that spirit and way of representing things. I started to make some collages, with silhouettes of writers, but they felt very weird. I didn't know where I was going. [*laughs*]

Citizen Kane was a totally new way to tell a story through a kind of collage. In that sense, it's a very written film. In it, you see something that you don't often see in cinema: a very powerful scene where the reporter, Thompson, goes into the library to look through a big book. If you think about it, there are not so many books in cinema. Try to think of films where books play a strong role. . . . So I was in this *Citizen Kane* mood when you brought me to the library. Immediately on entering you come upon a wall filled with drawers containing file cards, which is something from the past. This library is still not digital, so, to find a book, you have to look for it in this traditional way. But then I realized that this library starts in the *pre*-book era—from the codex, from types of documents that we don't even call books. Once when we visited, a codex was on view, wasn't it?

The Hispanic Society's library is an exciting place—many libraries are. This one has narrow corridors between shelves

the purchase of multiple existing libraries, its horde of treasures includes medieval illuminated manuscripts and herbals, a first edition of *Don Quixote*, documents pertaining to the Mexican-American War of 1846–1848, a Mayan codex, as well as portolan charts, *derroteros*, and other maps and atlases. ★ Such holdings have made this library, which is open to scholars and the public alike, a major research center for Hispanic studies. Although the narrowly defined remit of its founder still shapes its institutional profile, the Hispanic Society has gradually widened its mandate over the past half century to address the Latin American diaspora. It has thus acquired a number of colonial works of art, such as *casta* paintings, alongside textual materials that expand its library. But, with few exceptions, the institution's collecting policy has not ventured into the modernist era; those exceptions, which include several copies of works by Argentinean writer Jorge Luis Borges, have infiltrated its walls serendipitously, products of circumstance rather than policy.

When Dia Art Foundation commissioned Dominique Gonzalez-Foerster to create a site-specific project for the society's galleries, she gravitated to the library, where she immediately inquired about its holdings of twentieth-century literature. ◉ Ascertaining that these were meager, she began to speculate on extending the library into the present, into an annex that would be located in a gallery adjacent to the society's main building. ↠ Once occupied by the Museum of the American Indian (and now owned by the Hispanic Society), this modest ground-floor space was renovated in 2008 by Dia into a modernist, white-cube gallery for the presentation of contemporary artists' projects.[1] ⊠ Gonzalez-Foerster's proposed annex to the library would comprise three dioramas and a "textorama," a wall drawing woven from literary quotations and ciphers. ◼

Devised in 1822 by Louis Daguerre, coinventor of the daguerreotype, the diorama as a form was popularized at approximately the same historical moment as that when Huntington was preparing to put his collection on public view. By the end of the nineteenth century, it was employed by history museums of all types, particularly those devoted to natural history. Museum-sponsored field expeditions secured both prize specimens and

1. In 2007, Dia Art Foundation initiated a multiyear partnership with the Hispanic Society of America to bring exhibitions of contemporary art into their galleries. The series of shows began with *Fabiola*, a project by Francis Alÿs that was sited in the Hispanic Society's nineteenth-century North Building galleries (September 20, 2007–April 6, 2008). The next project, "Derrotero" (November 5, 2008–April 12, 2009), commissioned from Zoe Leonard, was a two-part project presented in this newly renovated gallery and in the gallery for temporary exhibitions located in the main building.

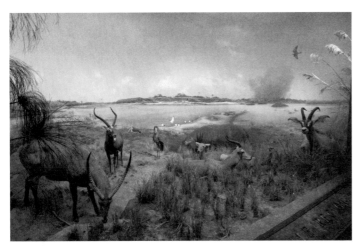

Upper Nile diorama, Akeley Hall of African Mammals,
American Museum of Natural History, New York.

ancillary materials such as plants and rocks for illusionistic mise-en-scènes, known as habitat groups, which were meant to provide audiences with simulacra of real-life settings. Today, as the form grows obsolete as a pedagogical tool, its mimetic function overtaken by new image technologies, dioramas have assumed significance as cultural relics; many of the older, more established natural history museums, among which New York's is unsurpassed, have taken on a new responsibility for preserving and restoring historic dioramas while at the same time introducing novel multimedia spectacles.[2] C

An ardent film buff, Gonzalez-Foerster gravitated toward this increasingly outmoded precursor to the cinema, renowned for its dexterous deployment of traditional pictorial techniques in service to panoramic verisimilitude. A team of specialists who are regularly employed at the American Museum of Natural History, where landmark dioramas continue to generate wonder, was hired to construct the three biotopes—climatic, geographic zones—that represent the Americas: the Atlantic, the desert, and the tropics. Their background murals derive from composite photographs of found imagery, while their three-dimensional displays have been culled and constructed with the scientific rigor that became a hallmark of this exacting form.[3] F Whereas habitat groups depict what seems an eternal and timeless present, Gonzalez-Foerster's scenes have clearly been subject to the vicissitudes of history, each bearing traces of previous human habitation in the form of an architectural structure whose ruins

2. Specialist conservators currently maintain the historic examples at New York's American Museum of Natural History, while other teams of technicians create new, mostly temporary, dioramas.
3. In fact, dioramas are set according to light conditions on certain days in specific seasons of certain years—a specificity indicative of the rigorously scientific approach to their creation.

of books. Outside that area, there's another corridor with little square windows, into which you can see the storage, kind of a surveillance system. It's very weird. From there, we entered an office that contained a large photograph of Huntington's library as it once was. I immediately tried to find traces of Borges. Knowing that he had also been a librarian, there was a chance that he might have been in contact with colleagues here. So we looked for letters and books and found several versions of *Ficciones* and a really great edition of *The Invention of Morel* by Adolfo Bioy Casares, a seminal book. I gave the librarian a long list of writers: some Brazilians, including de Andrade for his book on Brazilian modernisms, and a few Argentineans like Casares. The really important ones were there, but a lot of others were missing because it's not the point of that library to collect in this area. That's why it was so tempting to add an extension to the library and to organize it in a completely different way.

❖

I was processing this library thing while I was in Rio, in Brazil, when I got an e-mail that my own library in Paris had been flooded. (I have a place that is only for books. It's not in my apartment: it's a place where I don't bring anything else. And, as a library, it's arranged in a strange way.) Very bad news. I didn't know exactly how many books were wet or what had happened. I felt really disturbed. In Rio, at that moment, it was raining a lot. I then had a very strong impulse to drown a book—I think it was a book by George Perec, *Un Homme qui dort*. (It's an incredible book. Do you know it?) My reaction to my drowned library was to see what it feels like when a book goes underwater. When I started to put the book into the water I realized that it was floating. A book is full of air: it doesn't drown so easily. Only after it was soaked did it slowly, slowly fall down. Maybe that

was the real starting point for this project: my consciousness of the book as almost a living being, as something that resisted me in a physical way, something that was full of air and also, of course, full of signs. What happened in that moment was very liberating. I felt less stressed by the drowned library as I grew more excited about what had suddenly appeared—a book in relation to a specific moment and climate, to this very tropical situation. I started to think more about how books produce spaces and spaces produce books, how spaces become more like climates, places, and moments. I think this is how the whole thing started to become clearer.

⊠

I have two ways of working. One is ongoing research. Like everyone else, I read and go to see films, then there are moments when I get excited and one thing starts to connect to another or to a place, and this might lead to a film. (All of my films were made this way: in that sense, they play a special role in my work.) Exhibitions are different because they involve a situation. With them, I am more like an actor waiting for a good role. I get scripts, but often I'm not interested because they're not what I'm looking for: either I don't want to travel there, or I think the building is boring, or I know this story already, or I can picture the event too well. Sometimes, but not so often, the script falls exactly on the place where I am at that moment; it fits perfectly with what I'm obsessed with. In that sense, there's a quality of response in an exhibition, but it can only be a response because there was already some possibility for it to work. Like in the early years, I still react to places and their possibilities: it's difficult for me to imagine an exhibition out of nothing—I can't wake up and decide, "I will do an exhibition today." As opposed to more autonomous works, an exhibition requires a context. It's a medium of contexts. For me, context now has a more

presuppose an earlier, more prosperous era. More curiously, in lieu of wildlife, literature is their central subject: each contains a selection of books written by twentieth-century authors who lived or set their works in such locales, or are otherwise connected, in the artist's mind at least, with such environments. ⑤ The books, too, seem like relics, for their cover designs and typographies betray the fact that many were printed decades ago, while on others may be found traces of wear and use.[4] Some volumes are easily recognizable; most are so thoroughly embedded in their contexts as to be unidentifiable.

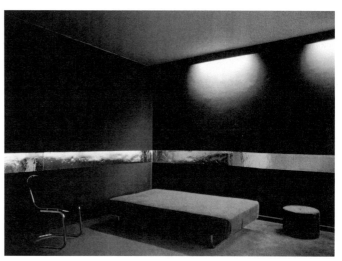

Dominique Gonzalez-Foerster, *RWF*, 1993. Installation view, Cologne.

Together with film and architecture, literature of many kinds has provided the artist with a lifelong source of stimulation and reference. **T** Her more comprehensive exhibitions often include a *tapis de lecture*, a signature work that incorporates a vividly hued carpet onto which have been piled a selection of new and used books, generally paperbacks, generally works of fiction and poetry. Unmoored in the gallery like a flying carpet momentarily at rest, the *tapis de lecture* provides a tranquil space for contemplation. Even though a serious or sustained engagement is unlikely in such circumstances, these disarmingly casual reading rooms encourage their audiences to reminisce over books read previously and to discover others unfamiliar or untried. By cross-referencing the remembered and the anticipated, ideas and subjects emerge that pertain to issues—material, formal, or thematic—that are explored in other works displayed nearby in

4. A list accompanying the exhibition brochure identifies the forty-eight books, mostly fiction, some poetry, all in their original languages, placed in each category. A few of these books were borrowed from the Hispanic Society's library—by Adolfo Bioy Casares, Jorge Luis Borges, and Mário de Andrade—others were purchased, new and used, in Brazil, Spain, France, New York City, and elsewhere specifically for this piece.

the exhibition. By contrast, the *Chambres* (*Rooms*), another of Gonzalez-Foerster's early series of works that developed in parallel with the *tapis de lecture*, function somewhat like detective novels; viewers discern a mood or coloration in a highly stylized but often personalized space by deciphering a terse set of clues relating to an individual. (*RWF* [1993], for example, conjures filmmaker Rainer Werner Fassbinder's private domain with a minimum of means: dark brown walls, a carpet, a chair, and a bed.) The narrative dimensions of these works remain open-ended in that the *Chambres* never gel as "image"; they never become legible as concrete representations of a specific space.

In melding fact and fiction, illusion and narrative, in ways that conjure the future as well as the past, Gonzalez-Foerster's dioramas are imbued with a mood or atmosphere closely associated with science fiction. This genre has long played a strong role in her imaginary and also, at times, in her practice, as seen in the recent large-scale installation *TH.2058* (2008), created for Tate Modern's Turbine Hall, which was reminiscent of a dystopian film set. The types of sci-fi literature to which she is drawn— stories by J. G. Ballard and Philip K. Dick, in particular—seldom posit fantastic interplanetary worlds inhabited by strange creatures; instead, their realms, even when afflicted by cataclysmic environmental or manmade disasters, remain familiar

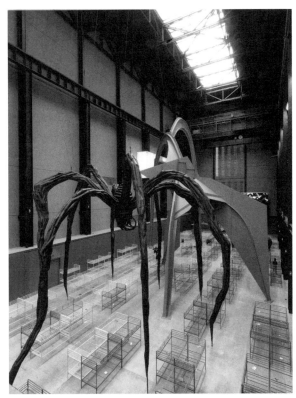

Dominique Gonzalez-Foerster, *TH.2058*, 2008. Installation view at Tate Modern, London.

historical dimension. I see it more as a time-based issue than a space-based issue. This is really obvious in the Venice film [*De Novo* (2009)] and also here at the Hispanic Society.

I made an incredibly exciting visit to the American Museum of Natural History. I'm sure most people know the dioramas, but they were still new to me, and there I first encountered the diorama as a medium in its own right. As you know, I am quite into exploring late nineteenth-century categories of precinematic display, such as the panorama, and thinking about where exhibition-making might have gone if cinema hadn't taken over the function of narrative. What might have happened if the panorama or some other form, like the diorama, which is another branch of that same tree, had assumed the task? The textorama came about when we were thinking about what kind of text to have on the front wall, didn't it? The issue of the wall text—the terrible wall text—which can be so damaging! [*laughs*] My first idea was to use the titles of the books that are in the three different contexts. But that seemed too didactic. The textorama is the opposite of the dioramas in that it offers the possibility of entering the text, which is an endless collage. It's like what happens when you enter a bookstore and you look at one book after another and build up a text of your own. Since you can't go into the books in the dioramas, they become something completely different: like strange new animals. The good thing is that the textorama becomes a kind of revenge of the text.

C
The diorama department in the American Museum of Natural History is slowly being closed, because 3-D or video is taking over. I feel that the movie *Avatar* [2009], which is all about immersion in an artificial context,

is a follow-up to the 3-D panorama in that it provides this totally immersive experience. Actually, it's the same thing, because the scenario's not so important; the music can be bad, and dialogues can be ugly. In natural-history museums in twenty years, there will probably be a whole section of 3-D moments in place of dioramas.

F

I am still not completely at ease with the diorama. It is double-edged. For me, it has a dark side that I'm still not completely sure about, that I can't really come to terms with. It has a hermetic quality: you can't touch anything. If you try, you bump up against the glass. They have a morbid quality that I'm absolutely not used to, although in other ways they are great. For me, this project only felt complete on the opening night, when I saw the way people looked at it. I feel an enormous sense of relief with the dioramas, in that I know nothing can happen when I am not there. [*laughs*] I'm relaxed in a way I have never been before. Every exhibition before this one has been something of a drama in that things don't remain how I want them. A guard would bring his chair in, or someone would change the lighting, and the show would no longer look the way I wanted it to. I've been fighting this for twenty years. It's a strange relief—but an almost depressing one—to deal with something that is completely finished. Do you remember that I wrote to you, saying that I didn't know whether this was the end or the beginning of something? I'm still not completely sure what it means.

S

I realized I was looking for something that was a much more intense kind of interaction. A library could be a place where books interact in a much deeper way with the context: not on the shelf, not on the table, not even on those carpets that I call *tapis de lecture*: in those situations,

and somewhat akin to our own. Key among the books incarcerated in *chronotopes & dioramas* is Ballard's *Hello America*, published in 1981. ⊛ Written in the aftermath of the 1970s oil crisis and subsequent economic recession, it limns a twenty-first-century situation in which the United States has voluntarily relinquished its national sovereignty, and its citizens have evacuated to Europe and Asia in the wake of devastating climatic change that enveloped the eastern part of the country in desert and brought tropical profusion to the West. Though they might seem direct, the parallels between Ballard's novel and *chronotopes & dioramas* are fortuitous: Gonzalez-Foerster read the book only after having conceived her piece. It consequently provided not a point of departure but, to her at least, an uncanny confirmation of the basic tenets of this project.

The quasi-scientific-cum-science-fiction ethos of *chronotopes & dioramas* accounts for certain inadvertent subthemes, among which the most remarked on are climate change and the redundancy of the printed book. ⊞ For Ursula K. Le Guin, whose cautionary fable *The Word for World Is Forest* (1972) is included in the tropical biotope, science fiction "extrapolates imaginatively from current trends and events to a near future that's half prediction, half satire."[5] Less satiric than mordant, the social references in Gonzalez-Foerster's dioramas reveal an uncharacteristically dark side. ♀

Sited literally on the backside of the dioramas, the textorama serves as their counterpoint. It comprises quotations from lesser-known works (rather than the acclaimed masterpieces) by several classic early modernists—Joseph Conrad, Franz Kafka, and Gertrude Stein—interwoven with others by both acclaimed and little-known post–World War II authors, some living, some deceased. Prompting reflections on national and cultural identity, on imperial and colonialist expansionism, and on the evolution of diasporic voices, this spatiotemporal ensemble constitutes an actual and metaphoric "open" work (in the sense defined by Umberto Eco)[6]: it encourages viewers to pay attention not only to the specific way a textual fragment is framed and conjugated but also to the ways in which such contextualizing may infiltrate and shape cultural production and how, by extension, cultural artifacts and ambiences impact the formation of subjectivities.

5. It is relevant to this project that science fiction is "still shunned by hidebound readers, reviewers and prize-awarders, . . . literary bigots [who] shove [its authors] into the literary ghetto." (Ursula K. Le Guin, "A Hymn to Her," review of *The Year of the Flood*, by Margaret Atwood, *Guardian*, August 29, 2009, p. 5.)

6. Umberto Eco claims that an "open work" depends on a viewer's freedom to interpret and explore its meaning. (See Eco, *The Open Work*, trans. Anna Cancogni [Cambridge, Mass.: Harvard University Press, 1989].)

Disposed loosely as three immense calligrams across the wall, the appropriated texts create schematic landscape forms, rhythms, and shapes that mimic the subjects of the dioramas. To the question spelled out in large letters, "What is geography?," several answers may be found. Appended in small type beneath the question itself, one is quite literal: "A description of the earth's surface." A second is filled with foreboding: "the time came when there was no occasion for geography." More cryptic still is a third, in which the word "GEOGRAPHY," written vertically in uppercase, is paralleled by "AND PLAYS." In this ludic terrain, topography comes to denote a set of cultural conditions rather than a location. Gilles Deleuze and Félix Guattari coined the term "minor literature" to denote a form of writing in which readers enter the work "without being weighted down by the old categories of genres, types, modes, and style."[7] As literary critic Réda Bensmaïa observes, their concept of a minor literature "permits a reversal: instead of [a] work being related to some pre-existent category or literary genre, it will henceforth serve as a *rallying point* or *model* for certain texts and 'bilingual' writing practices that, until now, had to pass through a long purgatory before even being read, much less recognized."[8] For Deleuze and Guattari, Kafka is the exemplary pioneer in this new literary continent, "a continent where reading and writing open up new perspectives, break ground for new avenues of thought, and, above all, wipe out the tracks of an old topography of mind and thought."[9] Gonzalez-Foerster's textorama arguably serves a similar function: as its structure morphs, its quotations become rallying points and catalysts, provoking new ways of associating and musing, conceptualizing and speculating.

Toward the end of *Bartleby & Co.*, Enrique Vila-Matas's literary and formal tour de force, the protagonist contends, "One of the more general differences that can be drawn between novelists before and after the Second World War is that those before 1945 tended to possess a culture which informed and shaped their novels, whereas those after this date tend to exhibit a total disinterest in their cultural heritage [apart from] the literary process (which is [inherently self-reflexive])."[10] While the statement may ring true for a certain strand of postmodern literature, it has no resonance within the recent writing included here by authors like

where the books are piled up around the edge of the carpet, you are free to read. In thinking about the books immersed in water, suddenly this Atlantic idea appeared, connecting groups of books with stories of going to America and of traveling between America and Europe, by Enrique Vila-Matas, Franz Kafka, Gertrude Stein, and others. This reminded me of the library in *Citizen Kane* and, then, of the Morgan Library and the Frick Collection, which also reflect a strong impulse on the part of certain Americans to display their relations based in memories to that continent.

T

I see myself as a failed writer yet still someone with a strong fantasy, an obsessive desire, to write. If in any sense I can be called a writer, then I'm a very minimalist one. I write in fragments and not, like Balzac, in endless sentences: I would rather put things into three words. The first rooms I created, the *Chambres*, came out of a long dialogue with what we call detective novels. The use of clues means that you have to reconstruct the thing yourself. Only the necessary elements are inserted, so that it seems reduced almost to a void. When you read a book, you have this intense relation with words, which means you fill it up with your own. We know and don't know how reading works. I was interested in bringing this way of reading into the exhibition space by providing a minimum set of signs or clues. For those who find the voids larger than the signs, these rooms are absolutely unreadable. Now, I, too, realize that they don't make sense: I had thought the net was very tight and trusted that the connections, the narrative's meanings, were contained in the rooms. Very slowly, I moved toward environments that had fewer holes and that made it less possible to escape. *Park—Plan for Escape* for Documenta 11 in 2002 was a group of objects from different places—a chair from Chandigarh, the phone booth from Rio . . .

7. Réda Bensmaïa, foreword to *Kafka: Toward a Minor Literature*, by Gilles Deleuze and Félix Guattari, trans. Dana Polan (Minneapolis: University of Minnesota Press, 1986), p. xiv.

8. Ibid.

9. Ibid.

10. Enrique Vila-Matas, *Bartleby & Co.*, trans. Jonathan Dunne (New York: New Directions, 2004), p. 166. In recent years, Vila-Matas has become a friend of as well as a mentor to Gonzalez-Foerster.

Each was distinct and unique. Each acted almost as a sculpture, but it was also a sign of something else. The work is all about the links between these objects. In a way, I saw it as a new type of garden. From that point on, the structures slowly became more complex, so I was a bit shocked to discover that with the Turbine Hall piece, *TH.2058* [2008], this old problem of leaving too many voids had come back.

J. G. Ballard's novel *Hello America* is almost like a program for this exhibition. It, too, has three moments—crossing the Atlantic, slowly going through the desert (which is New York engulfed in golden sand and huge dunes), to arrive in the tropics (which is Las Vegas). Though it underlines how deeply this exhibition is connected to Ballard, the relationship is not just based in this book but has many other facets. I was lucky to have a father who liked science fiction a lot, so I became immersed in it early on. I think reading Ballard at an early age changed my sense of beauty forever. Even when I was young, I felt that an abandoned road with a burned-out car and a woman with ripped clothes offered a much stronger aesthetic than something closer to perfect; I've always liked the way that big pieces of concrete are part of Ballard's vision of nature. Technology is not as strong a part of his science fiction as the question of how an atmosphere— a complete context—can transform someone. That's something I've wanted to explore by experimenting myself. One of the reasons I spend time in Rio is that I believe the brain can be changed by different conditions. In a modest way, I study myself in this context, how I react to it, what it does to me. After spending ten years in Brazil, I can see that it is reversing my relation to Europe. It's shifting my point of reference. Already changes have appeared, which I want to incorporate in my work because they're the basis for strange

Le Guin, Ballard, Dick, Thomas Pynchon, and William Gaddis. As their contributions make evident, worldliness need not be inimical to close identification with region or locality. Paradoxically, it is Vila-Matas's own books that are infused with a metanarrative rather than locational specificity. Amalgams of reference and citation, his novels resemble libraries, albeit libraries composed of quotations both real and invented. ☺ That they have proven ultimately highly influential for Gonzalez-Foerster's practice in recent years is demonstrated in both the textorama's innovative composition and its content.

If the dioramas' geohistoricizing biotopes fix a play of ideas within a given frame, the textorama provides the potential for activating Mikhail M. Bakhtin's notion of a chronotope.[11] Rather than defining places per se—that is, sites—this spatiotemporal construct generates a promenade that mobilizes references so that they ricochet off one another, gaining momentum from their interaction. As opposed to the narratives suggested by the dioramas, the textorama provokes a free-ranging playfulness. Together, the two strategies displace "the museum effect" associated with the white-walled gallery that literally frames them, in favor of promoting an experience more akin to that associated with a library: research infused with reverie.[12] While the contents of both the textorama and the dioramas are fundamental to the genesis of this project, their forms—their modalities of display— are ultimately equally critical to the work's meaning. If the diorama seems an almost obsolete form, the textorama (a relative of the calligram beloved of certain modernist poets, including Apollinaire) seems fresh and original, largely free of the overtones of bygone eras.

Whereas Gonzalez-Foerster's decision to create the dioramas came out of a very particular set of conjunctions, some fortuitous, some sought out, the impetus for the textorama was more mundane. Struggling with the perennial question of the exhibition wall text—that is, with the problem of how to introduce this exhibition to visitors, how to create a prologue that would frame and structure viewers' responses in relation to the project's governing premises—the textorama enabled her to foreswear a

11. See M. M. Bakhtin, "Forms of Time and of the Chronotope in the Novel: Notes Toward a Historical Poetics," in *The Dialogic Imagination: Four Essays*, ed. Michael Holquist, trans. Caryl Emerson and Michael Holquist (Austin: University of Texas Press, 1981), pp. 84–258.

12. This phrase was coined by Svetlana Alpers to characterize the way of seeing particular to the culture of these institutions, how attentive looking at crafted objects in isolation turns them into works of art. (See Alpers, "The Museum as a Way of Seeing," in *Exhibiting Cultures: The Poetics and Politics of Museum Display*, ed. Ivan Karp and Steven Lavine [Washington: Smithsonian Institution Press, 1991], pp. 25–32.)

single authorial voice in favor of a colloquy. Indicative of her willingness to probe what are considered the components basic to the format of an exhibition, this approach stems from an abiding preoccupation with conventions presumed in exhibition-making whereby exhibitions constitute a genre in their own right.

Crucial to her development and that of her colleagues and close friends Pierre Huyghe and Philippe Parreno, who also emerged in the early 1990s, were institutional critiques that burgeoned in the late sixties. By the 1980s, the conceptual platform constructed by such pioneers as Michael Asher and Daniel Buren was well established and had, in turn, spawned a new generation of inquisitors. These critiques reoriented and reconceptualized the practice of exhibition-making, as is evident in Buren's seminal *C'est ainsi et autrement* (*It's like this and that,*

Daniel Buren, *C'est ainsi et autrement*, 1983. Installation view at Kunsthalle Bern.

1983). Created for the Kunsthalle Bern, this installation embodies his newfound conviction that an exhibition could no longer be defined as a display of works of art; it was itself a work of art. Beginning in the late 1960s, exhibition typologies had become increasingly codified and refined as a result of certain curator-driven initiatives, among which the most notable were projects comprising specially commissioned artworks. Willoughby Sharp broke ground with "Earth Art," at the Andrew Dickson White Museum of Art at Cornell University in 1969 and "Projects: Pier 18," in New York City in 1971. Subsequent exhibitions devoted to site-specific public projects, such as Skulptur Projekte Münster (which began in 1977 and recurs every ten years), built on these precedents. Over time, these diverse strands forged a more reflexive recognition of the protocols of exhibition-making and encouraged a reformulation of its conventions and standardized display techniques.

connections. What does Clarice Lispector have to do with William Gaddis, or what does Roberto Bolaño have to do with Frank Herbert? Ballard is so interesting to visual artists because he specializes in this kind of immersion. In his books, you encounter very intense moments. He's also useful in that the main question his characters ask is: Do I stay or do I leave? Do I accept being contaminated by this desert, city, forest, climate, people, or, say, by this art? Or do I leave? It's a very important question. Because there is no fixed time limit, it's a question that often comes back when you're in an exhibition: Do I stay, do I leave? Why should you stay? Why should you leave? The exhibition form is great in that it still poses this question.

I've been following research on the electronic book for a long time—five, ten years. The idea was first launched long ago. Since technology can now make something so thin like the Kindle, it has finally reached a point where it appears a real alternative to traditional books. However, the great thing is to have both. It was the same with film and video: for me, there is no reason to make an exclusive choice. Jaron Lanier's most recent book starts with the phrase, "these words will mostly be read by nonpersons," to emphasize the fact that access by humans is but one small part of the scanning and storage of texts. Only last week I had two different requests for images to be used as illustrations in stories about "the end of the book." But that's not what I had in mind with this extension to the library. For me, the relation between text and space, and between climate and space, is far more important than envisioning the book as an endangered species. Although that's one possible reading of the project, it reduces it too narrowly. Climate change is also a part of this piece. It's very strong in

Ballard's books, which are based on questions like, What if suddenly it never stops raining? Or, What happens if there is no more water? Like with the question, Is this the end of the book? It's one part of the meaning here but not the main one.

◯

Some completely new thoughts have arisen recently that I didn't have while I was working on the project. For example, it's a bit apocalyptic. There's this "end of the world" feeling on account of the ruins of the modernist structures and the emptiness—the absence of humans. You wonder what happened; what might have brought those books there, and why there is nothing else. I think this was the more unconscious part. My principal focus was the question: Is it possible to expand this library, and, if so, how can it be done in a completely different way?

◉

Enrique Vila-Matas is an incredibly prolific writer. He never stops writing. I see his books as forming one ongoing book. They are a way of connecting all levels of experience, from reading to walking on the street to having a conversation with a friend. (Sebald is doing something similar.) Vila-Matas's way of creating a book in fragments, from endless quotations, is, of course, a Benjaminian way to write. I feel very close to his way of writing: it has contaminated me more than the work of any visual artist I can think of in recent years. A work like *De Novo*, my film for the Venice Biennale, is made completely under his influence. What's been important for me is his way of turning impossibilities, or difficulties, into a single story. The opposite of focusing on one main idea, it's a way of exploring different stages. And he's always inventing quotes, as well as using real ones—he's very happy to admit that some of the quotes he's made up have spread everywhere! Each of his books is itself a

When Gonzalez-Foerster went to the Kunstakademie Düsseldorf for a six-month period in 1986 as a visiting student, she encountered the lingering residue of institutional critiques that had long been nurtured there. A decisive part of the legacy of Joseph Beuys, they were also foundational to the practices of others who had been intimately associated with the school, including Buren himself. Much younger than her fellow German students, Gonzalez-Foerster did not identify with their interests. More memorable for her at that moment was her encounter with curator Kasper König, who was then deeply immersed in planning the second, greatly expanded, iteration of the Skulptur Projekte Münster, which he had cofounded a decade earlier. Though brief, this sojourn in the Rhineland was to prove influential as her thinking evolved from the early *Chambres* into denser environmental projects, of which *chronotopes & dioramas* is to date the culminating instance. ⊘

Gonzalez-Foerster's gradual foregrounding of exhibition-making per se may be traced in two recent pieces, *De Novo*, a poignant film she made for the 2009 Venice Biennale, and *Roman de Münster*, her contribution to the 2007 Skulptur Projekte Münster. Failure and anxiety are the ironic keynotes of the former, a wry, low-key twenty-minute piece, in which she recounts the litany of missteps that resulted from her engagement with this high-profile event on five separate occasions over a period of some twenty years. Relegated to a corridor of the former Italian Pavilion in the Giardini, *De Novo* was accompanied by an in situ work, *Untitled (Il Giardino dei Finzi Contini)* (2009), which was literally inaccessible and virtually invisible to anyone who sought it out in the far reaches of an abandoned garden in the Arsenale. In Münster, Gonzalez-Foerster began by surveying the fruits of the show's three presentations over the previous three decades, on the basis of which she then created a theme park, a sculpture garden filled with miniaturized replicas of the show's highlights. Not coincidentally, these small-scale versions in the guise of "plop" sculptures—hence the very antithesis of the exhibition's founding premises in site-specificity—prove enormously popular with children.

In *chronotopes & dioramas*, Gonzalez-Foerster addresses not only the institutional frame provided by the Hispanic Society but also that of Dia, the commissioning agent. ⊖ Dia's program at large, as well as specific works in its collection (such as the renowned Land artworks) and several installation-based commissions that formed part of its program at its West Twenty-second Street facility in Manhattan, has—somewhat consciously, somewhat unconsciously—influenced her proposal. Perhaps most pertinent is the work of Robert Smithson, a key figure in

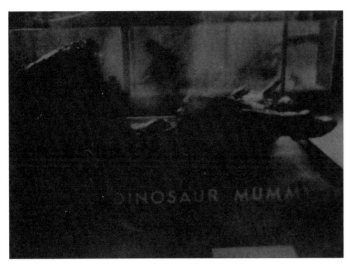

Film still from Robert Smithson's *Spiral Jetty*, 1970.

Dia's pantheon, who conceived of the Non-site, which he defined as "a three-dimensional logical picture that is *abstract*, yet it *represents* an actual site," as a means to confront issues of presentation and display.[13] Determined to find vehicles for realizing his ideas and works outside normative institutional channels, Smithson turned to a wide variety of media, including film, video, and the illustrated magazine article. Given its singular melding of footage of his Earthwork in the Great Salt Lake with diverse kinds of representation (stills of maps and documents, as well as scenes shot in the American Museum of Natural History's paleontology displays) and purloined texts with sci-fi overtones that comprise the narrative soundtrack—Smithson's film *Spiral Jetty* (1970) resonates richly with *chronotopes & dioramas*.

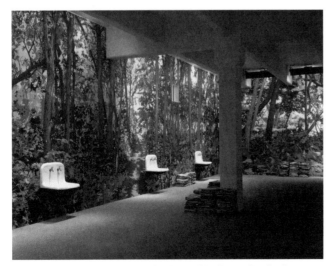

Robert Gober, site-specific installation at Dia Center for the Arts, New York, 1992.

13. "A Provisional Theory of Non-sites" (1968), in *Robert Smithson: The Collected Writings*, ed. Jack Flam (Berkeley: University of California Press, 1996), p. 364.

library, in which he establishes a field of connections between many writers, some of whom are totally invented.

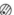

I've gone from the desert to the tropical, in that I began with very little. The early rooms have two aspects. One is connected to my small experience of being a museum guard and the trauma of seeing how little time people spend in front of works of art. How to build a kind of trap for the viewer became one of my permanent obsessions. In a sense, I've always been more interested in that than in finished or closed objects that you can pass by much too quickly, though there are some that are real traps and do keep your attention for a long time. The idea of the rooms was linked to a second idea, which was also there in my work very early on. It's a curatorial idea, in that it is more about the way you put things together than about the things themselves. When I first started to think about the rooms, I made a strong analogy between the rooms in which we live and the rooms in an exhibition, in the sense that a domestic place is an exhibition of the self, and an exhibition is another type of domestic space. I tried to produce a kind of circulation between them.

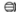

For me, as an artist, Dia provides a strong context because of the radicality and scale of what it has collected: the art it collects and maintains is so extreme. This project was contextualized by Dia and the American Museum of Natural History meeting at the Hispanic Society. [*laughs*] The natural-history museum offers a totally different approach to collecting, of course, but one that still has some connection to the other two. It shows a way of collecting biodiversity and life-forms and climates—which is yet another, completely different layer. I think I wrote to you one day and described this crossing,

didn't I? I don't remember exactly how I said that I thought that I'd found a solution for the idea of the library extension: the books would be organized according to different climates and geographies. This doesn't necessarily mean, for example, that a book is in the tropics because it's about tropical forests. Gaddis is not writing about the tropical, but he has a relationship to the tropical as I see it; and it's the same for the books that are found in the desert biotope. I thought about the *tapis de lectures* and other pieces I had worked on earlier, where you could actually touch the book: you could enter and read it. My growing excitement about the dioramas came from the fact they seemed to offer an interesting way to go deeper into what we could call an expanded literature. I think I've found a new way to organize books!

⊟

Recently, when I saw Duchamp's *Étant donnés,* I realized how fantastic it was to have the possibility of seeing it exactly as he so carefully planned it. I was so impressed with the fact that although, maybe, the place of one tiny branch has changed, it's basically exactly as he wanted it. And there is no interference from the context—as opposed to that of the ready-mades, which can be moved around or affected by the color of the walls or by interactions with other objects. Maybe in the future we will make contracts to keep exhibitions, which are so fragile as a medium, intact. I am still wondering whether keeping them fixed, like an image, is a solution or not. One day I might come up with an image, but I'm not there yet. As a mode of display, the diorama is not an image; it's still in the realm of exhibitions. Since it's completely sealed, it allows absolutely no interaction other than a visual one, and yet it's not an image. But because it's closed, it somehow offers the possibility of approaching it as you do with an object. And, as in any exhibition,

Among the more memorable of recent forays with the diorama over the past two decades were two installations commissioned by Dia—those by Robert Gober in 1992 and Ann Hamilton in 1993. Highly sensual, immersive environments, each derived its form and even content from conventions connected with the diorama. In a telling departure from tradition, viewers had to enter their complexly layered, multisensory environments. Gonzalez-Foerster has knowingly kept a distance from these and other contemporary engagements with the form, turning back instead to *Étant donnés* (1946–66), Marcel Duchamp's masterpiece created in secret during the last years of his life. ⊟ Among its distinguishing features is a peephole in the center of the massive wooden door that provides access to a bucolic yet unnerving image beyond. This device removes the scene from its immediate museal site—creating a separation between the institutional context in which it is located and the oneiric ambience it conjures. By drawing attention to the site in which it is experienced, Duchamp tried to ensure that his diorama could not simply be distilled as an "image"; he also prevented it from being distributed easily, on a par with other pictorial images.

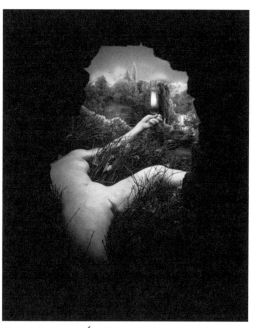

Marcel Duchamp, *Étant donnés: 1° la chute d'eau, 2° le gaz d'éclairage . . . (Given: 1. The Waterfall, 2. The Illuminating Gas . . .),* 1946–66.

Seamlessly weaving fact and fiction, Gonzalez-Foerster's dioramas neither permit a fully immersive three-dimensional encounter nor problematize the act of viewing per se. Their visceral charge stems from the dramatizing of the mise-en-scènes in the darkened corridor that provides their entry point. Suspension of disbelief goes hand in hand with awareness that their mode of address is hypothetical. In this, too, she does not

deviate from her prototypes that similarly hold art and science in tenuous balance. Among the most beloved of Manhattan's natural-history dioramas is one depicting a giant squid battling a sperm whale in the farthest depths of the ocean, an encounter in a place so remote that researchers have never actually witnessed the like. As the exhibit's label states, the composition, though based in scientific evidence, is ultimately "only an artist's conception."[14] Like those of the naturalists, Gonzalez-Foerster's read as indeterminate in that they, too, are suspended in a kind of temporal limbo; neither contemporary nor historical, strictly speaking, they raise the same basic question proposed by the squid and whale: What if these scenarios proved to be prophetic projections of some future moment?

Sperm Whale and Giant Squid diorama, Milstein Hall of Ocean Life, American Museum of Natural History, New York.

In contrast to the dioramas' investment in resolution and fixity, the textorama offers an arena for negotiation; whereas the diorama's format is hermetic, the textorama may be read as a score. As heuristic devices, these two display modes invite opposed, if not mutually exclusive, forms of address. In tandem, however, they provide a model for (re)considering ways in which an exhibition may be articulated and a library organized. Gonzalez-Foerster treats each venue—the library and the exhibition—as *a* subject, not *the* subject, of a project that incisively reviews the identities and the roles played by the institutions that generated it and now frame it. Above all, *chronotopes & dioramas* attests to our need to relish our modes of picturing, even as we acknowledge that, like reading, forms of exhibition-making are based in reverie as well as research.

you walk around. What I like about the diorama is that, although it shows a frozen world, it engages the body: you see a lot of nose traces on the glass. [*laughs*]

Excerpts from a conversation with Lynne Cooke (March 6, 2010) at the Hispanic Society of America, New York

14. I am indebted to Jennifer King's unpublished review of *chronotopes & dioramas* for this observation.

A WILD BOOKERY
Nine Reflections

Bradford Morrow

1.

We beget books, books beget us. Not only the manifestation of millennia of human ideas and deeds and memories, books are living entities, imagination's children. They have character, color, heft, smell, and meaning that differentiates each from the other, just as we do. And we, young and old, are their fathers, mothers, brothers, sisters, and ultimately their sometimes adoring, sometimes derelict descendants. Nor are libraries simply cemeteries filled with family "plots" but rather breeding grounds. A word is a heartbeat; a paragraph is a person; a book is a civilization.

Where a heart beats it may be stilled, but always at great risk. In a conversation with his friend and amanuensis Roberto Alifano in the early 1980s, Jorge Luis Borges remarked, "If books disappear, surely history would disappear, and man would also disappear." We lose our libraries and we lose not just our past, but our very lives. But what if our own hearts cease to beat first? What if books—history's and humanity's talismanic offspring—outlast and outlive us? Do we carry on within them, the pulse of cultures surviving in the vivid codes of language?

Imagine a family of books abandoned in the desert, their words blanching under the sun, some of their pages ripped out of their bindings by sand-clotted wind. Frank Herbert's *Dune*, Roberto Bolaño's *2666*, Borges's own *Ficciones*. Is history sundered along with them, and therefore humankind itself? And what if a book, say by Oswald de Andrade or Vladimir Nabokov or Richard Brautigan, is left beside a small mossy stream in the green canopied darkness of a tropical forest, discarded by invisible hands to the depredations of rain, mold, even furtive creatures who may or may not be hiding in the darker corners of this forest? Is that book truly a book anymore, or is it merely bound leaves of inked paper in the first stages of natural deterioration, an object that

was once the voice of narrative, of history, but now is devolving toward mute mulch on the lush vegetal floor? And if another book, one by W. G. Sebald or Franz Kafka or Federico García Lorca, is seen adrift underwater, its pages splayed in the deep blue currents like some aquatic bird—is it also still a book, or rather the remnant of a once-vital story now lost in briny oblivion?

Ezra Pound wrote that a book should be a ball of light in a reader's hands. But where have the hands disappeared to here? Where are the humans who built and once lived in the seemingly uninhabited Lina Bo Bardi house in Dominique Gonzalez-Foerster's tropical diorama? Where are the readers who evidently vacated or destroyed the concrete foundation in her central desert tableau with its terrifying, swirling ghostlike wisps of color trailing out toward the mountainous horizon? And what happened to the mariner who discarded the fishing trap resting on the Atlantic seafloor, perhaps at the same time he consigned his book into the waves? Is the abandonment of the objects that hold literature in their paper palms the abandonment of history itself?

2.

One does not visit Gonzalez-Foerster's *chronotopes & dioramas*, an installation that is nothing less than a dangerous garden of books, so much as one inhabits it. By turn, the installation inhabits its viewer, much as any of the books that populate its scapes inhabits a reader or, as William S. Burroughs in his essay "Creative Reading" wrote, "stays with the reader and becomes part of his inner landscape 'commensurate with his capacity for wonder.'" In a very real way, Gonzalez-Foerster has crafted a graphic essay, a sensual story, a palpable poem. To encounter her visual narrative is like coming upon a new kind of library. A wild bookery. An Athenaeum without walls.

The experience is curiously, complicatedly personal. Books, as objects, are usually found on bedside tables and reading-room shelves, in bookshop windows and the hands of people riding the subway or sitting on a park bench. To come upon a small group of them lurking in a jungle or floating underwater at once defamiliarizes and, oddly, vivifies them.

I become concerned for their well-being, find myself wondering how they got to be in these places. Who possessed them once upon a time? What endangers them now? Who, if anyone, will rescue them and breathe wakefulness, consciousness, into their pages by reading one of their first lines? Reading, "Once an angry man dragged his father along the ground through his own orchard." Reading, "The Nellie, a cruising yawl, swung to her anchor without a flutter of the sails, and was at rest." Reading, "First of all there is Blue."

It is a mystery, of course. A most troubling and compelling aspect of these dioramas is that the questions they pose continue to haunt us long after we have left the room to reenter the busy visual, aural universe of uptown Manhattan, emerge back into our own myriad narratives and interior stream of private vernacular. Our "inner landscapes" have been inalterably changed. Outside, on the living streets once more, the world itself has morphed into a codex, a dime novel, an incunabulum, and, above all, a kinetic memoir.

3.

Like an animal or a person, a book is asleep when closed and comes awake when opened. To witness the congregation of books that are sleeping here—not dead, for no book ever dies unless and until every copy of it is destroyed, and every last one of its readers has perished, and all commentaries, critiques, remembrances of it have equally vanished—is to call upon memory to awaken them, bring them fully to life.

I remember many of the sleepers present in these imaginary, dioramic worlds. I recognize many of their quoted lines on the vast white wall that greets us as we enter the room, a wall of carefully choreographed graffiti-quotes and author names, like an upturned table of contents. In their way, the dioramas that house these books parallel Marianne Moore's famous "imaginary gardens with real toads in them"—the real toads here being texts by Thomas Pynchon and Philip K. Dick, Patti Smith and

Ursula K. Le Guin and J. G. Ballard. Works by novelists, poets, science fictioneers, authors who implode genres and relandscape imaginary gardens even as they invent and nurture new ones.

Three books in particular draw me out of myself and into these universal spaces, not only because I intimately know the texts within, dreaming away in silence, but because I knew their authors and felt—still feel—a personal covenant with them. William Gaddis, Paul Bowles, and William S. Burroughs, the inventors of *Carpenter's Gothic*, *Up Above the World*, and *Naked Lunch*, are writers I'd esteemed long before befriending them in my twenties and thirties. Each of their books had such an impact on me that I now find myself pulled from the nocturnal darkness of the exhibit room, through the looking glass of the diorama, and into the scapes themselves. I find myself recalling not just the three diamond-prosed novels but the singular writers, my friends, who conjured them, also my friends.

4.

What a curious coincidence. The first time I ever had an extended dialogue with William Gaddis, I remember with surprised clarity, was at the annual spring reception outside the American Academy of Arts and Letters, on Audubon Terrace, just steps from where, nearly a quarter of a century later, I am "reading" *chronotopes & dioramas* in the Hispanic Society building on 155th and Broadway. It was 1985, the same year that Gaddis's third novel, *Carpenter's Gothic*, was about to be published. Gaddis, whose *The Recognitions* is a dark prose cathedral of a book, was worried. Or, at least, he was feigning worry.

The Vietnam vets are going to hate it, he said, in response to my question about the new book. And they're going to hate me for writing it.

Why? I asked.

One of my main characters is a vet who's a drunk, a wife beater, and a scam artist. Vets are going to think I believe they're all like him. I can already hear the complaints.

Gaddis had been attacked for writing a book before, of course. *The Recognitions* was widely, egregiously dismissed by the rabble of critics assigned by the best newspapers in the country to review it. Twenty years would pass before he published his second novel, *JR*, whose critical response was universally laudatory. And now he, who wrote so voluminously but published so few books, was

about to be onstage again, and I sensed he had no patience for this part of the process.

Whether he truly felt them or not, his concerns were ill founded. Far from prompting bags of hate mail, *Carpenter's Gothic*, a masterpiece of idiom and insight, was well received. When I read it not long after that conversation on the terrace, my thought was, and still is, that the protagonist Paul Booth to whom Gaddis was referring—alcoholic, monomaniacal, a double-dealing trickster and garrulous figure of vulgar tragedy and dark comedy—turned out to be far more an eighties Everyman of a morally bankrupt America than a war vet who'd fallen on tough times.

And as with Gaddis's earlier works, books informed this book. Indeed, within the walls of the Hudson Valley carpenter's gothic from which the novel takes its title, the vast sweep of Gothic literature is played out (the book reads like a stage drama at times and adheres to classic Aristotelian unities) even as it liberally appropriates—much like some literary incarnation of early hip-hop sampling—directly from Charlotte Brontë's *Jane Eyre*. Neither just a bleak portrait of a collapsing marriage nor the death-littered chronicle of a man who wallows in corruption, *Carpenter's Gothic* is a crisp indictment of a culture that has forgotten history while perverting what's left of it in the name of profit.

Gaddis's relationship with the book as artifact, as host to the arc of narration printed inside, was as unwontedly romantic as it was starkly pragmatic. For him, once a book was completed, published, it had no further need of its author. The author should retreat into the shadows and allow the book to stand for itself. Ideally, writers should become like shed skins as the glistening book moves forth into the world. At the same time, the careful braiding of so many traditional Gothic tropes into his postmodern construct—the mysterious stranger, the locked room, the gloomy ruined manse—shows Gaddis to be downright Borgesian in his embrace of the human library as both historical source material and inspiration.

What would Gaddis have thought, seeing *Carpenter's Gothic* in Gonzalez-Foerster's postapocalyptic world? He was never easy to predict. But for one, I believe he would have appreciated the company his book was keeping. And if in fact these dioramic scenes have an end-of-world narrative backgrounding them and, beyond a couple of architectural ruins, all that remains of civilization is a scattering of books, he might well shake his head as if to say, So be it. It was inevitable, after all.

5.

My first gesture, and in very slow motion, almost as if I myself am underwater, is to raise my right hand, palm forward and fingers widespread, and lower it toward the scene. At first, in the purposeful dense dark, I can't tell if there is glass between me and the life-size image before me. Of course I know there is, there must be. But the environment before my eyes is so compelling, so disturbing, that I'm not really thinking in the way one ought to when confronted by—by what?—a work of art in which works of art are distributed within poignant, artificial environments so weirdly convincing that one feels, or at least I do, the need to touch the glass that separates me from the vision captive inside. And how do the books regard me across the invisible divide that separates us? Those I have never read, do they in some wholly abstract way reach out toward me as I do toward them? Those whom I don't know, there on the far side of the heavy glass, are like strangers on the street. They have their lives, their opinions, and their stories and carry on perfectly well without me. It's I who need to reach through the glass and enter into a dialogue.

6.

In the work of certain writers, landscape achieves a status, an intensity and will, that raises it to a position of equality with personages we meet along the narrative path of story. Words sit still on the page, a typographic landscape, just as every visual gesture in these dioramas is fixed in place in scapes behind the glass. And by their being still and fixed, our eyes are set free to read each topographic nuance, thus to produce a dialogue between what we see before us and what we bring, imaginatively and experientially, to these works of art.

Of my three writers here—and it should be noted that Gonzalez-Foerster invites her readers to choose their own—Paul Bowles was surely the one who most clearly subscribed to the idea that landscape is more than background.

I never finally met Bowles in person. He and I only encountered each other on paper, in letters and inscriptions. My copy of *Let It Come Down* is inscribed with the words "The morning is a little boy. Noon is a man. Twilight is an old man. I smile at the first. I admire the second. I vener-

ate the last." I was no longer morning when he wrote these words for me, but neither was I noon as yet. Now that I am noon, I look back at myself as morning and ahead toward twilight, and I think of how richly Bowles's novels and stories have impacted my arc across the day. Standing in the Hispanic Society, I find myself remembering not just the harrowing heart-of-darkness journey Dr. and Mrs. Slade make from Puerto Farol into the nameless jungle where their destiny awaits them in *Up Above the World*, but the equally existential Sahara desert in *The Sheltering Sky* that will swallow Kit, Port, and Tunner, that novel's doomed threesome.

Landscape in Bowles's works is often terra incognita, a pitiless place where brutal forces conspire in the destruction of innocents abroad. As his characters set out into North African deserts or the tropics of South America, often for pleasure, on vacation, or simply to step out of their everyday lives to brush up against the exotic for a moment, they lose all contact with their points of departure. A Bowles-scape offers no escape. It is instead, in *Up Above the World*, a "tangled forest" that may appear to be a "relaxing landscape, made voluptuous by moonlight" when viewed from the safety of a lovely balustraded overlook edged by terraced lands and a circular pool. But of course this is a mirage, and innocence tinged by delusion is fatal. In the tangled forest the air itself is "evil."

If, in the worlds conjured by *chronotopes & dioramas*, books—and by extension exhibition viewers—are abandoned by their readers to the wiles of the landscape, with Bowles, characters—and by extension readers—are abandoned to the wilds of landscape by the narratives of his books. Either way, it's a dangerous adventure, and in both cases we are fortunate if we can hold to the fiction that glass or the printed page, each fragile as life itself, keeps us at a safe remove.

7.

Or, for instance, what if we extend the books-as-living-beings idea and view these dioramas as not postapocalyptic visions but natural-history displays in which we are offered a glimpse into worlds where books constitute the population? In doing so, we would enter into an interpretative adventure whose roots lie in anthropopathy, the attributing of human sentiments and passions to nonhuman beings—a dog, a god, a pond, a book. And yet, unlike a dog or a pond, these book beings are, by definition, endowed with human sentiments and passions. Given that, what possible better stand-in could there be for humans than the books they have written over the centuries? Just as the carpenter's gothic in Gaddis's novel is a house imbued with human characteristics—"a patchwork of conceits, borrowings, deceptions, the inside's a hodgepodge of good intentions . . . like the inside of your head"—and is a good example of a book employing anthropopathy as a means to animate setting, books for an impassioned bibliophile have a life beyond mere "shelf life."

8.

William Burroughs was friends with both Gaddis and Bowles, and like Borges believed that writing is magical in origin and central to human existence. His concept that words are a virus and we are host creatures was one I had always considered, despite plain-as-day assurances otherwise in his essay "Ten Years and a Billion Dollars" and elsewhere, richly metaphoric. That is, until I began spending many hours with him in New York at my place in the village or "The Bunker" on Bowery, and, later, at William's Sears & Roebuck house in Lawrence, Kansas. When he wrote, "My general theory since 1971 has been that the Word is literally a virus, and that it has not been recognized as such because it has achieved a state of relatively stable symbiosis with its human host," he meant just that, nothing less, nothing more. Similarly, his claim that "the Word clearly bears the single identifying feature of a virus: it is an organism with no internal function other than to replicate itself" is postulated with unadorned certainty. Burroughs's visions, and doubtless the teeming reveries that constitute *Naked Lunch*, had little or nothing to do with metaphoric filigree. He saw through matters and around the corners of ideas and wrote with a surgeon's dexterity, a stand-up comedian's deadpan, and an apocalyptic's serene fearlessness.

The first time I laid eyes on William was as a college student in the early 1970s in Boulder, Colorado. Allen Ginsberg, Gregory Corso, and Burroughs shared the stage at what was billed, probably fallaciously, as their first-ever reading together. The auditorium was packed, electrified. With the Vietnam War still raging, Ginsberg, a bearded bodhisattva channeling Blake, played his harmonium and chanted poems of peace. Corso read with lusty drunken humor his famous "Marriage" poem. And

William, dapper in his narrow tie and conservative gray suit, pale as an orchid, paper-thin, read from *Naked Lunch* with that stunning, ribboning drawl of his, a rich monotone with a razor edge that cut through the air. Hearing *Naked Lunch* come to life was at once galvanizing—it was as if I could hear him *thinking* the images as they corkscrewed into life—and highly infectious. Words that day were indeed viral, and it was only a matter of several incubating years before they would replicate and spread themselves through me.

How did this happen? Working as a bookseller at the far end of my twenties, I happened to handle a large collection of Burroughs books and ephemera, including the hand-corrected typescript of one of my favorite passages from *Naked Lunch*, the irrepressible "Dr. Benway." Collating these pages line by line against the original Olympia and Grove Press editions, I discovered an abundance of variations between the published texts and the one I held in my hands. Remembering Burroughs's words "*Naked Lunch* is a blueprint," I wrote him about this variant manuscript and offered to publish it. Not only did he write back giving me permission, but he provided a new introduction for the book, which was done in a letterpress edition of five hundred copies in time to honor the twentieth anniversary of the novel. Thus began a friendship, begat by a book, that would continue for years.

A dynamo of energy, never flagging, always full of stories, Burroughs, it seemed, never slept. Once, during one of our many discussions about animals—we both loved cats, and he always hoped to travel to Madagascar to see his beloved lemurs—William described to me with an unflinchingly straight face a fat white snake that lived in South America. This snake, he averred, barked like a dog and could crawl up walls and across the ceiling. I no longer recall the Latin name that he, like some brazen herpetologist, surely invented. But seeing the book dozing beneath the canopy of pendant leaves in Gonzalez-Foerster's tropical composition, I could easily imagine William's chimerical snake, too, lazing behind one of the rocks along the stream scree that meanders up the hill, as cunning and diabolic as Benway himself.

9.

If Borges's words about man, history, and books are reversed, so that his statement reads, "If man disappears, surely history would disappear, and books would also disappear," does the basic truth of the tenet hold? It is interesting that a book, as Gaddis recognized, once written and dispersed into the world, moves so far beyond its progenitor and first readers that it acquires a longevity of its own, making it independent of all who fostered it. Certainly, in Gonzalez-Foerster's vision, Borges's "man" has vanished. But his history, contained in the treasure boxes of his books, remains. Once again, Hippocrates' aphorism *Ars longa, vita brevis* is proven right, even though over the centuries it's been widely forgotten that the art he was referring to had nothing to do with paintings or poetry, fiction or sculpture, but the physician's art of saving, cultivating, and sustaining life itself. But then, as I would imagine Borges and indeed all of these writers would agree, a library is nothing if not a place of healing and survival.

Dès que tu fermes les yeux, l'av...
ommeil commence. A la pénombre c...
hambre, volume obscur coupé par...
où ta mémoire identifie sans peine...
que tu as mille fois parcourus, le...
partir du carré opaque de la fenêtre,...
lavabo à partir d'un reflet, l'étag...
l'ombre un peu plus claire d'un li...
masse plus noire des vêtements...
cède, au bout d'un certain...
deux dimensions, comme...
sûres qui ferait un très...
tes yeux, comme s'...
perpendiculairer...
tableau qui,...
ment gri...
formes, l...
posséder au...

... même café. Tu lis le *Monde* de cinq à

... vêtements avant de te coucher. Tu
... ta chambre chaque samedi matin.
... chaque matin, tu te rases, tu laves
... dans une bassine de matière
... cires tes chaussures, tu te laves
... bol et tu l'essuies et tu le
... sur l'étagère. Tu ouvres
... même minute, au même
... façon, la bande de papier
... ton paquet quotidien de

un paquet de gauloises ... 1,35
une boîte d'allumettes ... 0,10
un repas ... 4,20
une place de cinéma ... 2,50
un pourboire pour l'ouvreuse ... 0,40
le *Monde* ... 0,00
un café ... 1,00

Il te reste 5 francs 25 pour ton second repas ...

...ssettes, tes deux chemises.
...cier que tu as déjà lu vingt
...Tu fais les mots croisés
...traîne. Tu étales sur ta
...ges de treize cartes, tu
...sept de cœur après le six
...après le sept de trèfle, le
...e roi de pique après la
...e cœur après le dix de

que tu ne choisis plus...
tes lectures, ni tes ve...
Tu te laisses aller...
suffit que la foule...
Champs-Élysées, il...
précède de quelque...
rue grise, ou bien un...
lumière, un bruit, un...
mur, un groupe, un...
des grilles, des a...
clouté, une devan...
plaque de rue, la...
mercier, un escalier...

...re sur du pain, tant
...des biscottes, si tu en
...ans le pot.

Tu marches ou...
tu ne dos pas. Ti...
remontes. Tu...
pas. Tu mange...
t'assieds, tu...
glisses dans...
allumes une...
traverses la...
au billard électr...

...ette étroite, mains
...genoux haut. Tu
...vres. Des filaments
...de haut en bas à la
...es les fissures, les
...nd Tu regardes ton

Parfois, tu r...
ta chambre, ou...

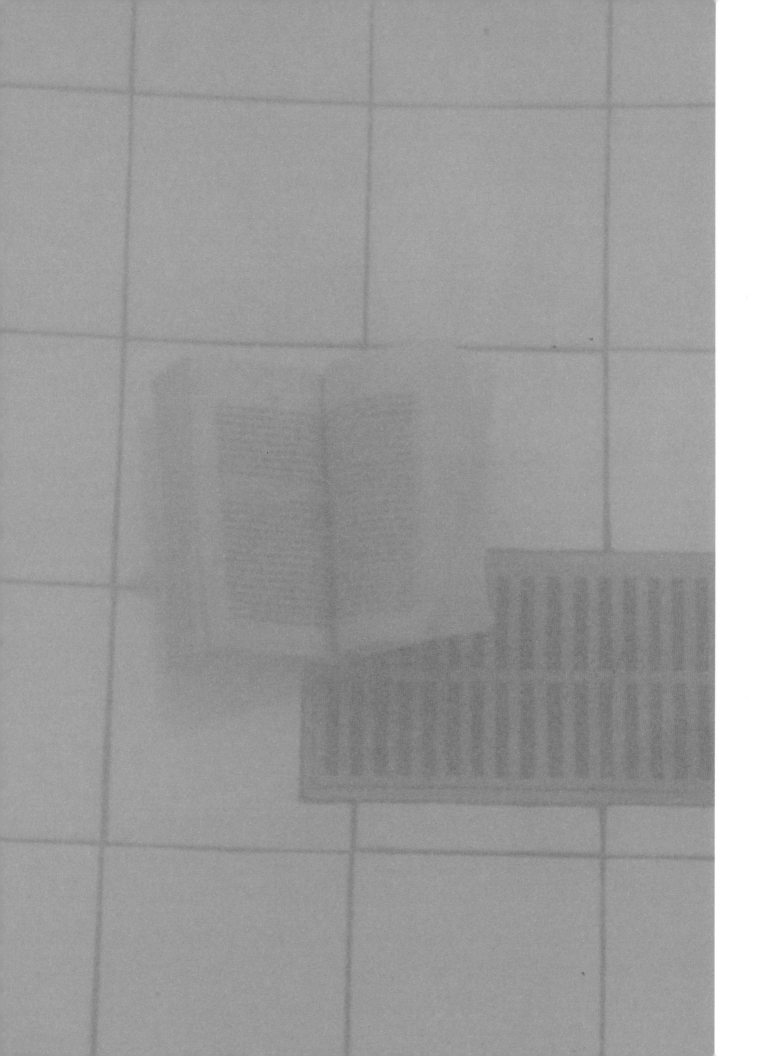

ROGER SMITH HOTEL

Enrique Vila-Matas

Leaving the Painting

The radio's playing "My Little Basquiat," by the Cowboy Junkies, one of those bands that hurt because they dig down into the depths of your soul only to plunge you into twilight. A triple enchantment: that of the sonorous beauty of this song; the elegiac, if you will, air of dusk; and my profound hypnosis before *Stairway*, the small painting facing the bed.

There's a mystery in this scarcely known canvas by Edward Hopper, a reproduction of which the Roger Smith Hotel has seen fit to hang in this room, facing the poor guests' bed. I think I'd be quite capable of pursuing, as far as necessary, the stories of previous occupants of this room, the silent story of all those who've passed through the same obsessive place that I now find myself and where I stand bewildered, almost motionless, looking uneasily at *Stairway*.

Evening falls; the window is open: the low hum of voices and a whole range of urban sounds, conversations sounding louder in the twilight, heavy traffic on Lexington Avenue. The moment has a truly elegiac air. The daydreams and memories of all that has happened throughout the day gradually absorb the world around me as I hear, more and more clearly, late-night human voices, windows slammed suddenly shut, the laughter of strangers. Everything appears to be in touching harmony with my nervous disquiet this evening. Disquiet over the small painting I'm studying as if all the emotion gathered by the day now drawing to a close were still intact.

I'd like to go outside, but the reproduction of *Stairway* seems opposed to the idea. In the small canvas, the viewer is looking downstairs toward a door that opens onto a dark, impenetrable mass of trees or hills. The only time I'd seen this painting before was in the great poet Mark Strand's book on Hopper. If it hadn't been for the book, I'd think this painting didn't exist. I've searched the Internet and never found a single image of *Stairway*. But I know it was painted in 1949 and can be found in the Hopper

collection in the Whitney Museum of American Art, just north of this hotel. I could go there, but I can't make up my mind.

In *Stairway* we look downstairs toward a door that opens onto a dark, impenetrable mass of trees or hills. Strand remarks in his book that while the entire house seems to be telling us to leave, everything outside it seems to ask: Where to? For Strand, everything the geometry of the house prepares us for is denied us in the end. The open door is not an innocent passage between inside and out but rather an invitation paradoxically extended so that we might stay where we are. "Leave," says the house. "Where to?" asks the landscape outside. All this recalls a phrase of Kafka's: "They went far away to stay right here."

It wouldn't be at all strange if the staircase in the horrific house in Hitchcock's *Psycho* had been inspired by this little painting by Hopper, whose reproduction has for a while been keeping me transfixed in this room. After all, Hitchcock, when he made the film, not only knew the painter's work, which by then had begun to be widely appreciated by the American public, but was directly inspired by Hopper's painting *House by the Railroad* to build the strange house where Norman Bates and his mother live in *Psycho*. So it's very likely that Hitchcock didn't stop at the facade of a Hopperesque house but used this strange *Stairway* for the set of its gloomy interior that invites us to go outside at the same time as it tells us, "For God's sake, don't move."

It happens a lot with this painter: we witness the most familiar scenes with the feeling that for us they are essentially remote, even unknown. Strand says that if there are people, for example, who are staring off into space in a Hopper painting, these people seem to be anywhere except where they actually are, lost in a mystery the paintings can't reveal to us and that we can only attempt to guess. The mystery of *Stairway* is for me the greatest of them all, even if this is only because it's in front of me now, placed in such a way that it couldn't be any more obsessive, and paralyzing me besides, leaving me incapable of walking out of the room.

I think I want to move, go out. My situation is the same as that of anyone who observes a Hopper painting, although the painting I'm studying is only a reproduction, and the place I want to escape from is none other than my own room. Anyone who looks at a Hopper gets caught up emotionally by the formal elements that always conflict in his paintings and produce opposing feelings in any viewer: to leave or to stay, to simply observe the mystery or to decipher it.

I think I want to go for a walk, to go out. To leave or to stay, that is the question. Ever since I found out the Whitney Museum is only blocks from here, I've done nothing but wait for the moment I manage to break the spell and can leave the painting and move, go and see the real painting, the one waiting for me outside: the one that's more real, I suppose, even if this is only because it's the original and because to see it—this must be a condition of the real—I must leave the painting and the room and leave the hotel and cross a few streets, go not very far, but rather nearby, as if I were going to stay.

The Painting That Isn't There

Do you remember? Seven days ago I stopped writing my piece *Leaving the Painting* at the point when I was getting ready to leave a hotel room in New York where for a long time I'd been trapped, hypnotized by a reproduction of *Stairway*, a small canvas from 1949, a little-known painting by Edward Hopper. In it, the position of the viewer obliges one to look downstairs toward a door that opens onto a dark, impenetrable mass of trees or hills. And Mark Strand said that the open door is not an innocent passage between inside and out but rather an invitation paradoxically extended so that we might stay where we are.

– Leave—says the house.

– Where to?—asks the landscape outside.

When I learned that the Whitney Museum—where the original painting hung—was located a short distance from the hotel, I'd begun to wait for the moment—remember?— when I'd be able to break the spell and leave the painting and the room to go and see the one that awaited me out there, a few steps from the hotel: the real painting.

I must leave—I said to myself—the room and the hotel, and cross a few streets, go not very far, but rather nearby, as if I were going to stay.

But all of this was no more than an invented situation, written in my house in Barcelona. A text entitled *Leaving the Painting*, which I published for you all last Sunday wanting to make you believe I really was at the Roger Smith Hotel in New York and that the Hopper painting had kept me immobilized there.

Today I really am in New York, in that hotel. I arrived in the previously imagined room yesterday. And as one might expect, the painting in my room was not *Stairway*.

It's true: I have a nasty habit of relating trips before I take them. But what can I do? It's the way I am. Remember what the scorpion said in that joke made famous by Orson Welles in *Mr. Arkadin*: "I can't help it. It's my character!"

Let me make it clear that I never used to do such things. The truth is that it has to be some sort of second nature that ultimately leads me to write—before experiencing them—the travels I embark on. The fact is I think I'd have died of fright if, on arrival in my room in the Roger Smith, I'd really found this painting, *Stairway*, that in Barcelona I'd imagined was in my room in New York. In its place there was another. More interesting than what I was expecting. It was an engraving from the beginning of the past century in which there were two oceanographers out at sea. I photographed it. But I carried on imagining it was the Hopper painting. Afterward, I pretended I'd spent hours trapped in the room, hypnotized by the reproduction of *Stairway* and that, as soon as I went outside, the first thing I'd have to do was go to the Whitney Museum and see the real painting. Almost without realizing it, I started to live what I'd previously written and even published as something already experienced: one more way of imitating the Roman Petronius, who wrote stories in which he was the protagonist, until one day he decided to *live* what he'd written.

In order to break the spell I needed to leave the painting for real. I called Andrea Aguilar, a journalist friend who's lived in New York for a year and a half and who now has a truly Kafkaesque job. For the *New York Times*, where she worked for a while, as for the travel magazine where she now works, she performs the task of verifier or fact checker, that is, she's in charge of meticulously making sure that not a single false fact infiltrates the articles she's given to edit. There is no doubt that if she had to check the facts and correct my tales of travels written before taking the trips she'd have her work cut out for her.

I didn't know she worked as a fact checker when I suggested she accompany me to the Whitney, just as I couldn't have known—or even imagined—that she was a friend of Mark Strand's, the poet who wrote the best book on Hopper and author of the wonderful pages that led to my interest in *Stairway*.

I didn't find out Andrea was a fact checker until we were already on our way into the Whitney. So neither of us could imagine that what we were really doing in the museum that morning was *verifying* that the painting wasn't there. We confirmed that the collection Hopper's widow had bequeathed to the Whitney was to be found on the

fifth floor, and that's where we went. We calmly followed the route through the various galleries on this floor and, at a certain point, after having been there for half an hour, we started to see paintings we'd already seen two or three times, which led us to deduce we'd already seen everything being exhibited and there was no trace of *Stairway*.

Andrea, suspicious that I'd invented the painting, and very much in character as a fact checker, spoke for a long time with two of the museum's security guards. And from what they told her she worked out that the little painting must be either in the basement or else in some part of the world where there was a traveling exhibition of Hopper's work.

Andrea finally accepted that *Stairway* wasn't a fictitious painting. But knowing that it was real, knowing it existed, gave her a strange eagerness or desire to see it and touch it. She suddenly found the painting's invisibility frustrating, since it wouldn't allow us the experience that morning of being in front of the canvas and staring down the stairs and feeling them inviting us to leave the museum at the same time as keeping us glued in front of the painting, wondering where we were thinking of going. None of this could happen to us now, given that the actual painting wasn't there. I thought this was a sign of the times and helped to prove once and for all that modern art, unlike ancient art—which was inconceivable without relating it to a sacred place—is *portable* art, highly fugitive or itinerant.

If, as Félix de Azúa said in his *Diccionario de las Artes*, "every aesthetic relationship requires a *place*, since it never occurs in the vacuum of pure consciousness," it's no less true that as I see it Hopper's painting *doesn't have a place*; I don't know where to see it, except that I imagine it hidden behind the engraving of the oceanographers. Is there perhaps a *place* behind this engraving found in a room, number 1109, at the Roger Smith Hotel? Although the facts have not been checked or even verified, there could be an imaginary basement that glides acrobatically through the vacuum of my consciousness.

The Passenger on the Tuscania

Every time I enter room 1109 of the Roger Smith Hotel, I study the enigmatic engraving with the two oceanographers out at sea. I've already photographed it, I've studied it on the most diverse occasions, and I've even taken it down to see if I could

find any more information on the back. But the little picture is what it is. Strange, especially because of those small, mysterious dioramas that, together with some spyglasses, can be seen near the bottom of the canvas, on the wooden boards of the ship's deck. Inside the dioramas, books can be seen submerged in three different environments like three states of the soul: tropical, oceanic, desert.

The strange atmospheres the dioramas appear to contain now hold my gaze and keep me from taking my eyes off the engraving. Who are these oceanographers who've supplanted my *Stairway* and who also act as hypnotists? What are those dioramas doing there on the floor? Are there dioramas on the high seas? And, as well as all this, is *Stairway* hidden behind the oceanic engraving?

According to the hotel management, the "insignificant picture in my room" is very likely an illustration from an old edition of a book by Joseph Conrad. If the dioramas seem mysterious to me, they also do to the staff. But they just manage the hotel and don't resolve artistic enigmas for guests. This is what they said to me and they, certainly without meaning to, have managed to offend me. Because I'm not asking for anything, I'm not asking them to resolve any enigmas for me, but I do want to know why they've put this picture and not another in my room. I'm sure everything can be explained.

– So, you can't tell me why there was a different picture in the room last week?

– A different one?

– A Hopper that's now untraceable.

They frowned and let me understand that my assertion was disconcerting.

They've never had a Hopper, they declared very seriously.

Furthermore, they are not entirely sure that the oceanographers' engraving comes from a book by Conrad. The only person who could have reliably confirmed this died last year.

I've thought hard about it and I can't waste time trawling through every edition of Conrad to see if I can find this engraving with spyglasses and dioramas, and so I'm going to focus on the remarkable coincidence that the only book accompanying me on this trip is a collection of essays by Joseph Conrad, *Notes on Life and Letters and Last Essays.*

It really is a coincidence, and I never discard such chances.

Among the essays is one entitled "Ocean Travel," which describes sea voyages and says they're not what they used to be. No doubt, this text could have been illustrated

perfectly with the engraving of the two oceanographers out at sea that I have in front of me at this very moment—in the middle of the beautiful New York twilight—as I write these notes.

As I watch how the shadowy light of dusk slowly glides into the very corners of the room, I decide to imagine that the engraving of the oceanographers could originally have been an illustration for "Ocean Travel." And I don't plan to turn back from what I've imagined now.

"To contradict what we imagine merely helps reduce the life of our spirit," Vilém Vok used to say. So I assume everything is true and carry on my way and return to "Ocean Travel," and there I find an apologia of liberty and also a beautiful description of the different climates that must be traversed by every great imagination wishing to cross, from one end to the other, a bridge, a life, a great novel, a star, a moon, a diorama.

These are more coincidences and chance happenings than I expected. And enough to make me think the connection between the engraving and me is not a superficial one. But establishing the depth of this connection seems like an arduous task. All I know is that Conrad wrote "Ocean Travel" for the *Evening News*, with the sole aim of making some money during the voyage he took on the *Tuscania*, the ocean liner on which he sailed to the United States for promotional purposes in the winter of 1923, one year before his death. Conrad was a man of the sea who never thought he'd end up being a "passenger" and in his article he sets out—in the same vein as two he'd written previously against the offensive luxury of the *Titanic*—his protest against the ghastly changes experienced on ocean crossings since he'd sailed: "It was otherwise with the old-time traveller under sail: he had to acclimatize to that moral atmosphere of ship life which he was fated to breathe for so many days. He was no dweller in an unpleasantly unsteady imitation of a Ritz Hotel."

In general, change for the worse is one of the constants in humanity's history, and high literature has devoted centuries to discussing this persistent phenomenon. The thing is that humans seem to change continuously, but always into something worse. In "Ocean Travel," Joseph Conrad talks, fully aware of what he's saying, of the destruction of the old concept of a voyage on the high seas and laments the loss of a sense of solitude and adventure. Now not even the sea is what it used to be, he says. Above all, he adds, when one looks at it through the fish-eye porthole of an immaculate cabin.

But it's also true that, as critical as Conrad was of transatlantic luxuries, he chose a first-class ticket for his crossing to the United States. Perhaps he sensed that he was never really so terribly at odds with personal comfort. And it seems not a single night went by that he didn't dine in style at the captain's table. Not that I'm reproaching him. I, at least, am not one to do so. I'm not one for anything. I'm not. Or, rather, I'm merely someone who, here in this room at the Roger Smith, waits for the endless spell of the oceanographers' engraving to be broken. Someone who's here, trapped, with his gaze hijacked by this seascape, by this anonymous engraving that's intrigued and bewitched me more than *Stairway*, which is really saying something. I'm merely someone who's become a recluse who looks incredulously at the spyglasses and dioramas. Someone who looks at all this and suspects that beneath the engraving might be Hopper's canvas. Someone who from time to time thinks he hears a voice in the background that, in spite of the distance, comes to him from the hotel reception and says:

– We don't solve artistic enigmas for guests.

No, of course not. Hotels aren't there to decipher mysteries of dioramas on the decks of Conradian ships. Although in that case, why are there pictures in hotel rooms? I don't know. I think that outside, on Lexington Avenue, the traffic has literally gone crazy.

Translated from the Spanish by Rosalind Harvey and Anne McLean

Creo que esta isla se llama Villings y que pertenece al archipiélago de Las Ellice.

America
is nothing
if not
spacious

Los desiertos de Sonora
(1976)

I carried the book
a hundred yards
into the desolation,
toward the southeast.
With all my might I threw it far out in the direction she had gone.
Then I got into the car, started the engine,
and drove back to Los Angeles.

WIRT RODDY

SMOKE
RISING

En la biblioteca
municipal
de Hermosillo,
Belano,
Lima y yo
buscamos
el rastro
de Cesárea Tinajero.
No hallamos
nada.

¿Qué hay detrás de la ventana?

ENRIQUE VILA-MATAS

2666

ARTURO BELANO

ULISES LIMA

VUDÚ
U
R
B
A
N
O

JOHN FANTE

All
along
the coast,
in places
like Leonardo,
Atlantic Highlands,
Little Silver,
Ocean Grove,
Neptune City,
Belmar
and Lake Como,
they built summer palaces
for their families
and villas for their women
and usually a church as well
d a little house for a chaplain.

THE WAVES ROSE UP FROM THE DEEP AND CAME ROLLING ON WAS TERRIFYING, HE SAID.

habe mich verirrt," sagte Karl,
nd der Fahrt gar nicht so bemerkt,
in schrecklich großes Schiff."

De ces villes ne restera que ce qui
un jour les traversa: le vent…

LA INVENCIÓN DE MOREL

Hoy,
en esta isla,
ha occurido
un milagro

THE EMIGRANTS

The
ship
had
already
slowed.

Una tarde, se embarcó en Veracruz
en dirección a Nueva Orleans.
Embarcarse significó para
él renunciar a la poesía.

W. G. SEBALD

C'était si facile de rester. D'observer. De sentir.
De rester.

A
Buenos Aires,
les jours
rallongent
lorsque
arrive septembre.
Tu n'y as jamais pensé,
n'est-ce pas ?

Und morgens wie abends und in den Träumen der Nacht vollzog sich auf
dieser Straße ein immer drängender Verkehr, der, von oben gesehen, sich
als eine aus immer neuen Anfängen ineinandergestreute Mischung von ver-
zerrten menschlichen Figuren und von Dächern der Fuhrwerke aller Art dar-
stellte, von der aus sich noch eine neue, vervielfältigte, wildere Mischung von Lärm,
Staub und Gerüchen erhob, und alles dieses wurde erfaßt und durchdrungen von
einem mächtigen Licht, das immer wieder von der Menge der Gegenstände ver-
streut, fortgetragen und wieder eifrig herbeigebracht wurde und das dem betörten
Auge so körperlich erschien, als werde über dieser Straße eine alles bedeckende
Glasscheibe jeden Augenblick immer wieder mit aller Kraft zerschlagen.

Aujourd'hui, j'ai envie d'écrire sur Buenos Aires.

La Biblioteca Brautigan reúne exclusivamente
manuscritos que, habiendo sido rechazados por las editoriales
a las que fueron presentados, nunca llegaron a publicarse.
Esta biblioteca reúne sólo libros abort
a
d
o
s.

"Ich
"ich habe es währ
aber es ist

Tout le monde sait que ces villes
furent bâties pour être détruites.

Cambié
los discos;
las máquinas
proyectarán
la nueva semana,
eternamente.

The whole of the Lower East Side
was one huge dormitory.

April 7.
It is eighteen months since
M. first proposed coming
to America. Spring rains
are over, we are told. It will
be dry until November.

Possessing things
was
a technique
of consolation.

THE WAY

an

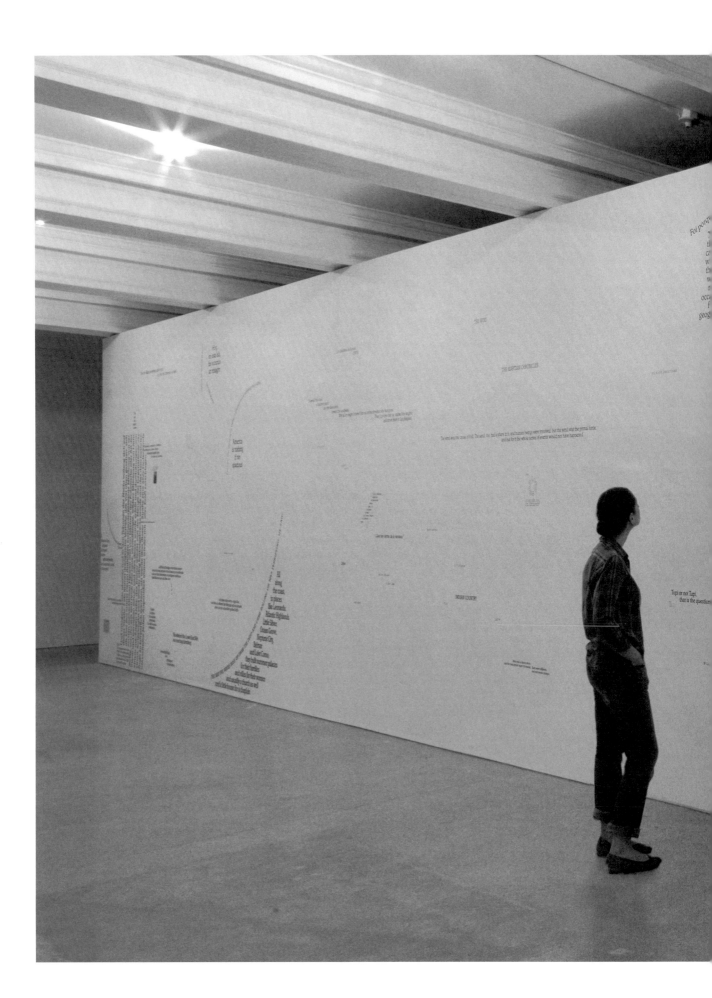

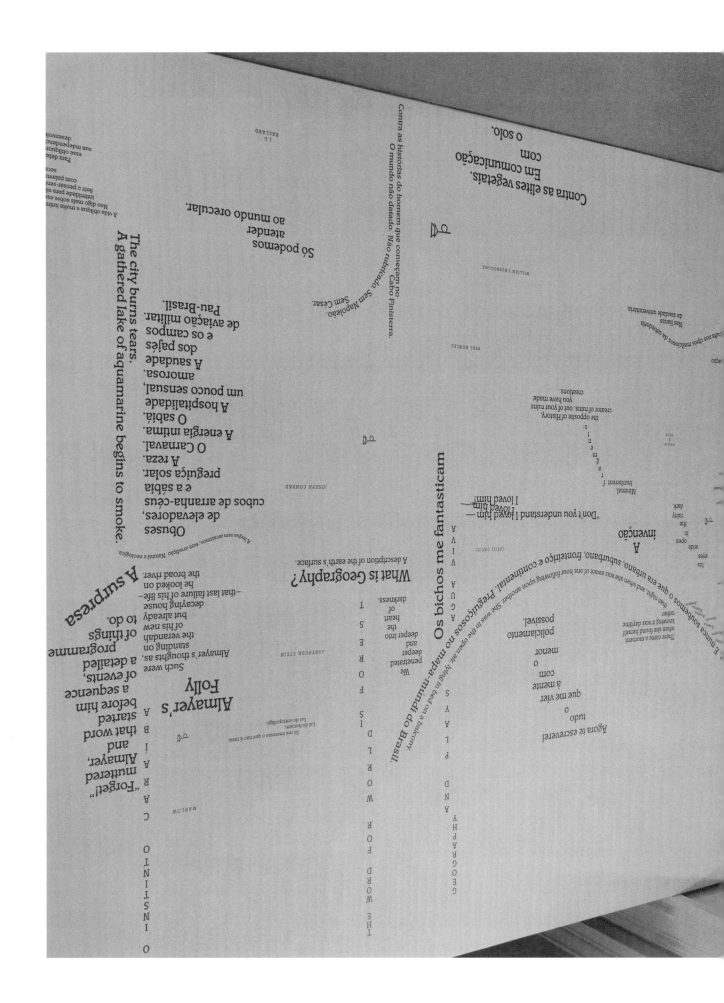

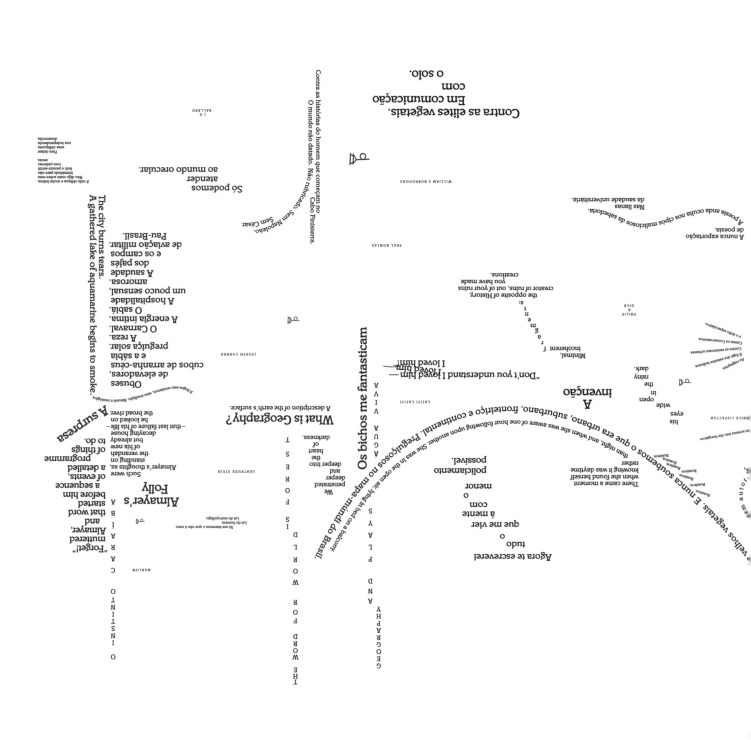

Em comunicação
com
o solo.
Contra as elites vegetais.

Contra as histórias do homem que começam no
O mundo não datado. Não rubricado. Sem Napoleão. Sem César.
Cabo Finisterra.

J.G. BALLARD

Só podemos
atender
ao mundo orecular.

WILLIAM S. BURROUGHS

Nas lianas
da saudade universitária.
A Poesia anda oculta nos cipós maliciosos da sabedoria.

A nunca exportação
de poesia.

Para deixar
esse obliquona
sua independência
desenvolta.

A vida oblíqua e muita íntima.
Não digo mais sobre essa
intimidade para não
ferir o pensar-sentir
com palavras
secas.

The city burns tears.
A gathered lake of aquamarine begins to smoke.

Pau-Brasil.
de aviação militar.
e os campos
dos pajés
A saudade
amorosa.
A hospitalidade
um pouco sensual.
O sabiá.
A energia íntima.
O Carnaval.
A reza.
preguiça solar.
e a sábia
cubos de aranha-céus
de elevadores,
Obuses

PAUL BOWLES

you have made
creator of ruins, out of your ruins
the opposite of History,

PHILIP K. DICK

Minimal,
Incoherent f
r
a
g
m
e
n
t
s:

JOSEPH CONRAD

A description of the earth's surface.
What is Geography?

GERTRUDE STEIN

We
penetrated
deeper
and
deeper into
the
heart
of
darkness.

A surpresa

programme
of things
to do.
A detailed
programme
of events,
a sequence
before him
started
that word
and
Almayer,
muttered
"Forget!"

MARLOW

Almayer's Folly
Such were
Almayer's thoughts as,
standing on
the verandah
of his new
but already
decaying house
—that last failure of his life—
he looked on
the broad river.

Alguma sem ancestrais, sem emoção. Natural e melódica.

Só me interessa o que não é meu.
Lei do homem.
Lei do antropófago.

O INSTINTO

THE WORLD FOR WORD IS FOREST

Os bichos me fantasticam

E nunca soubemos o que era urbano, suburbano, fronteiriço e continental. Preguiçosos no mapa-múndi do Brasil.

"Don't you understand I loved him
— I loved him!"

CATITI CATITI

ÁGUA VIVA

A invenção

CLARICE LISPECTOR

the scents into the bungalow.

velhos vegetais.

Agora te escreverei
tudo
o
que me vier
à mente
com
menor
o
policiamento
possível.

There came a moment
when she found herself
knowing it was daytime
rather
than night, and when she was in the open air, lying in bed on a balcony. She came a moment of one hour following upon another.

his
eyes
wide
open
in
the
rainy
dark.

GEOGRAPHY AND PLAY

THE WIND

THE MARTIAN CHRONICLES

The wind was the cause of it all. The sand, too, had a share in it, and human beings were involved, but the wind was the primal force,
and but for it the whole series of events would not have happened.

MARY AMANDA

LITTLE CROW

INDIAN COUNTRY

YLLA

LETTY

Mars was a distant shore,
and the men spread upon it in waves. Each wave different,
and each wave stronger.

Foi porque nunca tivemos gramáticas, nem coleções de

O verdadeiro pensamento parece

MANIFESTO ANTROPÓFAGO

The
time
came
when
there
was
no
occasion
for
geography.

RICHARD BRAUTIGAN

This
was
a red
jungle.
There were
floor lamps
and rugs
in the clearing
and rows
of books
back in the
shadows.

Escrevo-te em
desordem, bem sei.
Mas é como vivo.
Eu só trabalho
com achados
e perdidos.

The noise of the palms swishing in the dark came through

And all those
flecks and
blobs of land
were covered
with trees.

Ocean: forest.

Tupi or not Tupi,
that is the question.

WILLIAM GADDIS

background, island, surface, dunes, rocks, skyline, sky, marsh, canopy, forest

graphic elements in literary works

, nem coleçõ

O verdadero pensame

T
O
A
N
T
R
O

P
Ó
F
A
G
O

This
was
a red
jungle.
There
floor la
and ru
in the
and r
of bo

no
occasion
for
geography.

Escrevo-te em

All along the coast in places like Leonard Atlantic Highl Little Silver, Ocean Grove, Neptune City, Belmar d Lake c

...AME ROLLING ON WAS

that starts with the Atlantic, continues in the desert, and gets lost in the forest

like an ancient era

a textual panorama in English, Spanish, French, German, and Portuguese with illustrations

each text in its place and forming the landscape

Stendhal / *The Life of Henry Brulard*
Dostoyevsky's drawings > books
the inkblot drawings of Victor Hugo
the engravings in the books of Jules Verne
Arno Schmidt
Adolfo Bioy Casares
Thomas Pynchon
W. G. Sebald

his
eyes
wide
open
in
the
rainy
dark.

o in the clearings"
and rows
and books
of books
back in the
shadows.

some text *came through the screens into the bungalow.*

CLARICE LISPECTOR

And all those
flecks and
blobs of land
were covered
with trees.

cean. forest.

As migrações:

A fuga dos estados tediosos.

Contra as escleroses urbanas.

Contra os Conservatórios

e o tédio especulativo.

and visual art, a case of a frustrated writer

an archive room with a very special light

—that las... he loo...

the broad ri...

...darkness. Natt...

and
deeper into
the
heart
of
darkness.

S

T

What is Geography?

A description of the earth's surface.

A língua sem arcaísmos, sem erudição.

Obus...

de elevador...

cubos de arranha-cé...

e a sáb...

preguiça sol...

A re...

O Carnav...

A energia íntin...

O sab...

A hospitalid...

um po...

JOSEPH CONRAD

Citizen Kane at trial, the thirst of evil,
(procès/alphaville)
The third man

ENRIQUE VILA-MATAS

C'était si facile de rester. D'observer. De sentir. De reste...

À
Buenos Aires,
les jours
rallongent
lorsque
arrive septembre.
as jamais pensé,
Tu n'y
...ce pas ?

Bob Dylan
All the texts
The films of Todd Haynes

The book in American literature
(To) meet the author

Deleuze in American literature
(to) find the passages

There came a mon...
when she found herself
knowing it was daytime
rather
than night, and when s...

e velhos vegetais. E nunca soubemos o que era urbano,

A
invençã...

Roteiros.
Roteiros.
Roteiros. Roteiros.
Roteiros. Roteiros.
Roteiros.

esso pensamento parece sem
a u t o r.
O This
P was
O a red
F jungle.
A There were
A floor-lamps
G and rugs
O in the clearings,
and rows
of books
back in the
shadows.
...the dark came through the screens into the bungalow.

CLARICE LISPECTOR

his
eyes
wide
open
in
the

all those
and
land
vered
...

Borges, Gaddis, Pynchon, Bolaño, Dylan, Welles

Almayer's Folly

Such v...

hought

standing

the veran

of his r

but alre...

decaying ho

Almayer's

Só me interessa o que nao é meu.
Lei do homem.
Lei do antropofago.

GERTRUDE STEIN

W
O
R
L
D
I
S
F

A natural history in American literature
Climatic history

of ... already

but house

decaying house

—that last failure of his life—

he looked on

the broad river.

DE STEIN

A língua sem arcaísmos, sem erudição Natural e ne...

Obuses

de elevad...

Cubos , ...

California
Flying pages (thirst of evil)

A
Buenos Aires,
les jours
rallongent
lorsque
septembre.
arrive jamais pensé,
Tu n'y as jamais pas?
n'est-ce
n'

Tropical forest
Brazil, Florida, Caribbean
Rotting books

Cities engulfed
New York – London – A.I. (Artificial Intelligence 2001)

ichos me fantas

G U A V I V A

CATITI CATITI

policiais.

sem was

Preguiç

possível.

owing upon another. She was

o e continental. Pregui

rstand I loved him—
I loved him,
I loved him!

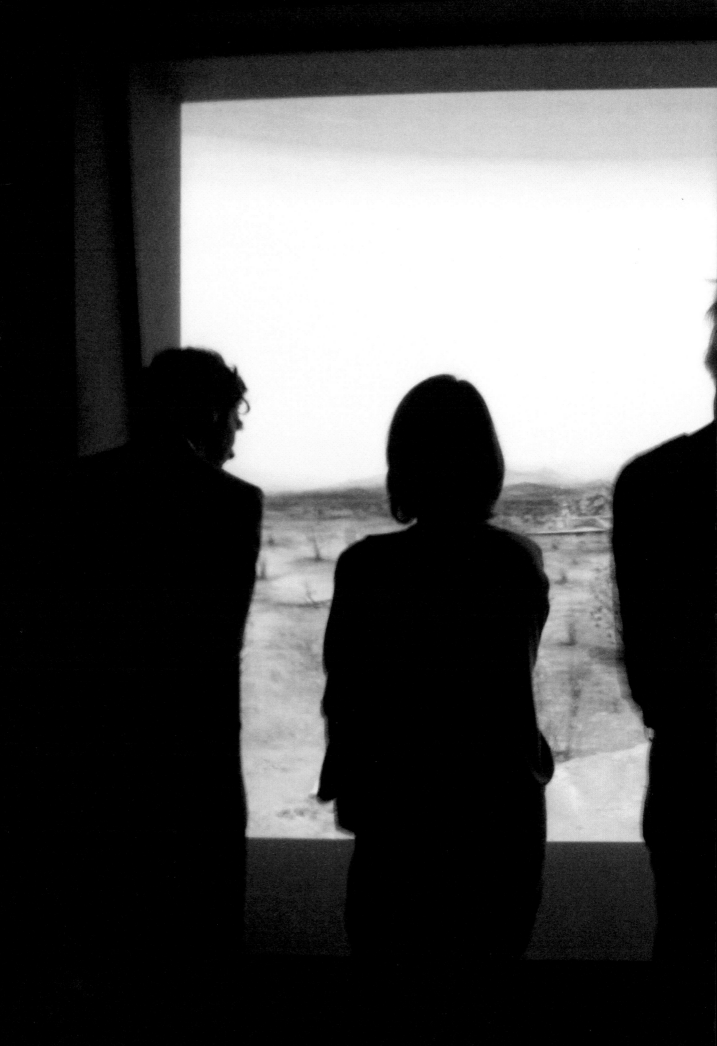

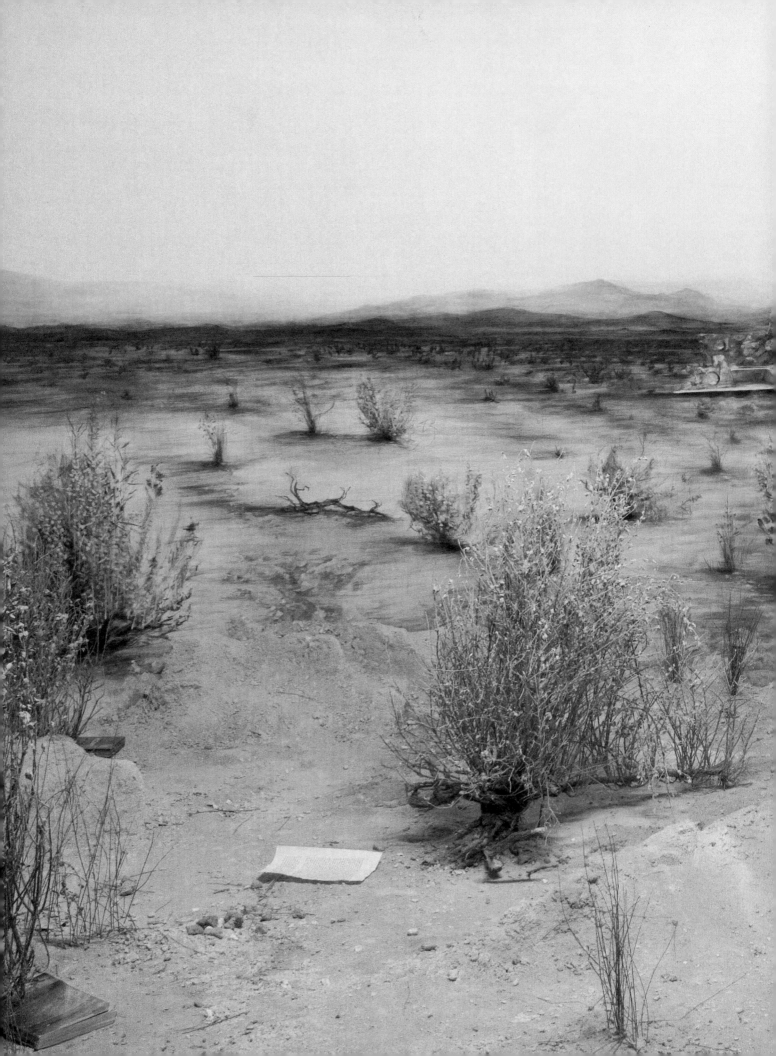